CENTRAL SWINDON

THROUGH TIME

Mark Child

AMBERLEY PUBLISHING

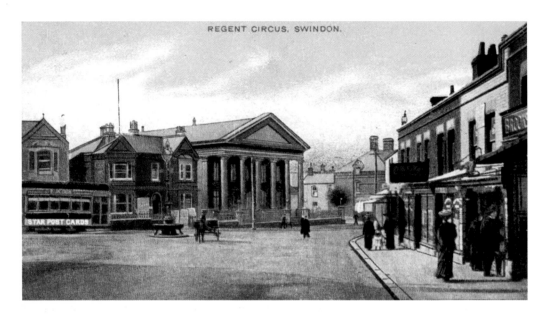

REGENT CIRCUS, SWINDON.

The Main Road to York

In the 1850s, the owner of Upper Eastcott Farm built a small terrace adjacent to farm cottages, named it York Place and rented the properties as residential accommodation and shops. These developed into a run of sixteen buildings, erected along the line of the shops shown in this picture. York Place was extended into a square, 1886–88, and shopfronts were put up around 1890. A number of villas were built on the west side of the square in the late Victorian and early Edwardian periods, opposite the newly built local authority offices. York Place had brief periods as York Square and Trafalgar Square, before being named Regent Circus in 1900.

This book is dedicated to Adrian Ralph Critchley (1924–2012), who, as a young man, lived in Carr Street and knew the area from the Glue Pot to the Rifleman's, and most of the old pubs in between!

Front Cover

The south-east end of Regent Street, celebrating the Coronation of Edward VII in 1902, and as it appears photographed from the same spot 110 years later.

Back Cover

The original High Street (now Emlyn Square) of the railway village pictured in the early 1980s, and the Glue Pot which was built there in the 1840s as a retail shop.

First published 2013

Amberley Publishing
The Hill, Stroud, Gloucestershire, GL5 4EP
www.amberley-books.com

Copyright © Mark Child, 2013

The right of Mark Child to be identified as the
Author of this work has been asserted in accordance with
the Copyrights, Designs and Patents Act 1988.

ISBN 978 1 4456 1400 7 (print)
ISBN 978 1 4456 1415 1 (ebook)

British Library Cataloguing in Publication Data.
A catalogue record for this book is available from the British Library.

Typesetting by Amberley Publishing.
Printed in Great Britain.

Introduction

Before the 1840s, Swindon was a small town built around the summit of a modest hill. Today, this area is called Old Town. On the sides of the hill stood isolated cottages, a few small knots of dwellings, and the occasional farmhouse; these were all joined by farm tracks and lanes. From 1804, the Wilts & Berks Canal crossed the moist and murky landscape of the plain immediately to the north of the hill, and the town's merchants in coal, coke, wood, salt, corn, etc., all worked their wagons from the waterway, importing, exporting, and serving the rural community that made up the predominantly agricultural county town of Swindon. Then came Isambard Kingdom Brunel and Daniel Gooch, backed by Parliament, steam, the Industrial Revolution, and thousands of uncompromising navvies in moleskin trousers with picks and shovels. Between them, they cut the Great Western Railway Company's line across the plain a few hundred yards north of the Wilts & Berks Canal.

The Company commissioned a railway station, which opened in 1842, and almost immediately set about building 'an engine establishment' close to it. Thus, in 1843, began the Swindon Works, and with it the need to import hundreds of workers and their families and give them somewhere to live. Part of the answer was the model village, now known as 'the railway village'. The first two streets were built 1842–43, and the plan was for 300 cottages arranged on a grid plan on two sides of a central square named High Street. The square had custom-built public houses and shop premises, and soon a market house. Most of it was built at the expense of the contractor, who was to be reimbursed over time by the rents levied on the properties. This village was the springboard for New Swindon, or New Town; Swindon on the hill became Old Town or Old Swindon, and the two were not about to give up their independence anytime in the foreseeable future.

Old Town overall had a legacy of modest public architecture, but architecture nonetheless, and a reasonable number of architect-designed villas. Outside the railway village, residential New Town was largely in the hands of speculative builders, many of whom had not hitherto built in volume. They applied terrace mentality to meet utilitarian criteria, and always had an eye to profit. Wave after wave of red brick, occasionally relieved by dressings and minor decorative motifs in stone, broke on the shores of the railway village, lapped around the foot of the hill, then gradually rolled over it. Viewing these late nineteenth-century streets now, one is made aware of how infinitely better they would look if they had been left alone, especially when one sees the occasional, rare and original frontage extant in a run. Unrelieved red-brick and stone dressings might have been boring, but it was an honest concept. Over the decades, aspirational owners have been allowed to clamp a wide variety of pretentious claddings and renders to their frontages in abandoned juxtaposition, often subverting the past and creating disharmony. It has turned central Swindon's residential streetscapes into a discordant muddle.

The problem with having to rapidly build a place from scratch to meet an immediate and pressing need is that the accompanying social and trading infrastructure may lag behind. So it was with New Swindon in the 1850s. The railway village was not self-sufficient in trade, but several factors initially precluded Old Town's businessmen

from rising to the opportunities it presented. The residents and traders on the hill were generally wary of their industrial neighbours, viewing with suspicion non-agricultural activities and by implication its exponents. Even had they wished to be more entrepreneurial, there were initially no properties in the embryonic new town from which established Old Town businesses might readily trade. Before that could happen, land had to be bought, and speculative builders had to build on it.

While all of this was going on, the people of New Swindon huffed and puffed up the hill, and descended laden with shopping. They gradually established their *bona fides* and broke down prejudices. They also widened and deepened the trackways between Old Swindon and New Town, creating the routes that would become the main thoroughfares.

One of these, although not initially the main one, or even the most favoured route, ran more or less between the railway village and Upper Eastcott Farm (roughly where Regent Circus stands today), at some point crossing the Wilts & Berks Canal. Thereafter, this route ascended the hill to Old Town through gardens and orchards. Public houses and places of nonconformist worship were put up alongside the track leading to Upper Eastcott Farm, and little groups of houses, too, some of which quickly gave over their front rooms to trade. As the speculative builders went into overdrive, custom-built shop premises were put up alongside the front-room shops. More businesses, often owned by traditional Old Town businessmen, set up in the railway village and the adjacent streets. The road out of the railway village became Bridge Street, part of the track to Upper Eastcott Farm became Regent Street – eventually the town's main shopping centre – and the route up the hill became Victoria Road. Central Swindon is where modern Swindon was born out of blood, sweat, tears, and fiery furnaces, and which developed out of opportunity, entrepreneurialism and need, into the focus of commerce and trade.

Acknowledgements

I am indebted, as with the companion volume *Swindon Old Town Through Time*, to Bob Townsend and Andy Binks for photographs from their own collections as well as from those of The Swindon Society, which they hold. Thanks also to Darryl Moody for pictures from the Swindon Libraries' Local Studies Collection, of which he is in charge, and for his technical help; to Pam Bridgeman for images by the late Denis Bird, in which she holds copyright, and to private collectors H. W. (Doug) Davis, Diane Everett, Colin Vance and to Paul Williams who holds the William Hooper collection for allowing some of their images to be used.

About the Author

Mark Child is a writer on history, architecture and topography. Amberley has also published his *Swindon Old Town Through Time*, *Abbey House & Gardens Malmesbury* and *The Windrush Valley, A guide to the river, towns and villages*. His other books include *Wiltshire County Guide*, *Discovering Churches and Churchyards*, *English Church Architecture A Visual Guide*, *Hometown History Swindon* (for children), and *Swindon, An Illustrated History*.

On the Lines

The first tramcar journey was made in Swindon in 1904; the last one took place in 1929. Three routes converged on the junction of Bridge Street, Fleet Street, and Faringdon Road, destined for the market square in Old Town, Gorse Hill, and Rodbourne. Mayor James Hinton can be seen in the leading tram as it noses its way through crowds around Regent Circus at the opening ceremony.

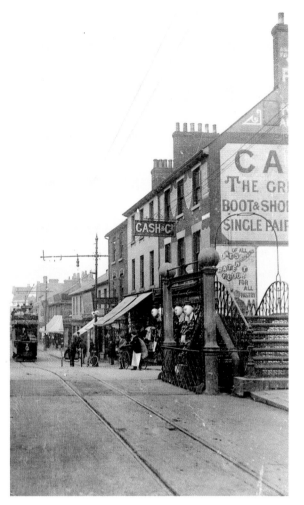

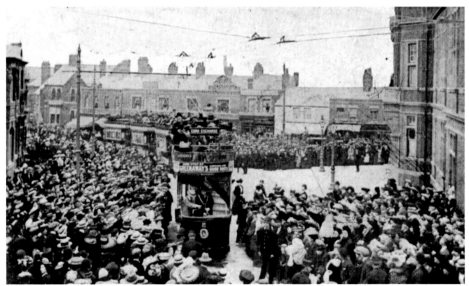

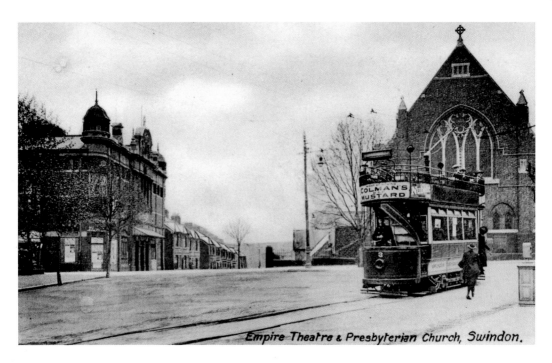

Empire Theatre & Presbyterian Church, Swindon.

Electric Travel

Tramcar No. 3, supplied by Dick, Kerr & Co. of Preston, Lancashire, can be seen at the foot of Victoria Road, at approximately the same spot where, in 1906, tramcar No. 11 crashed onto its side, resulting in five deaths and injuries to thirty other people. The picture of the packed tram can be dated to around 1914, the year the Electra Palace picture house (advertised on the side) opened in Gorse Hill.

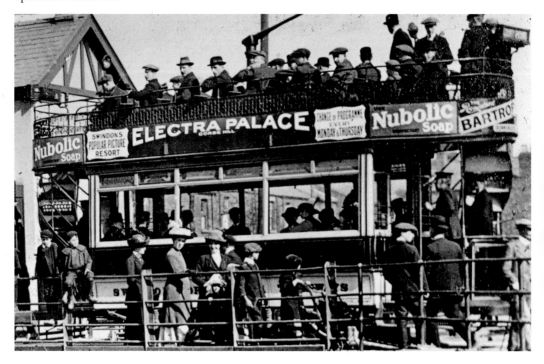

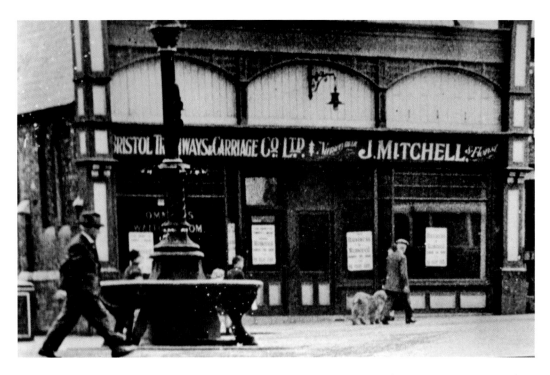

A Picture of a Place

The Bristol Tramways & Carriage Company Limited opened in Swindon with a single omnibus in 1921, setting up their office in the one-time premises of the Picture House, on the east side of Regent Circus. Their bus was parked in Eastcott Road. When King George V and Queen Mary came to Swindon in 1924, their offices were patriotically dressed.

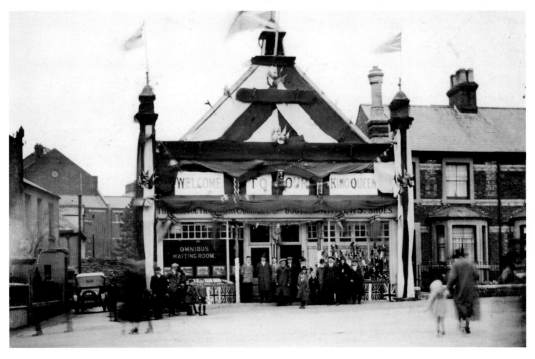

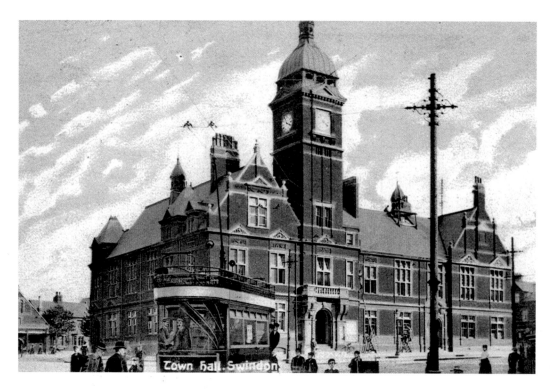

From Head to Toe

The town hall was built, 1890–91, by J. Reed of Plymouth, to the designs of Ipswich architect Brightwen Binyon, as offices for the New Swindon Local Board. It was the administrative hub of the town and the focus for special occasions, such as the visit by King George V and Queen Mary in 1924. In modern times the building has housed Swindon's reference library and dance studios.

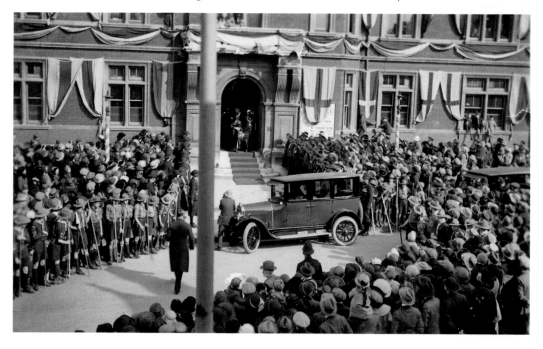

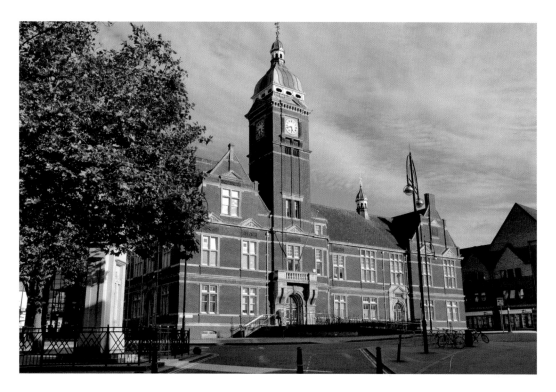

Nice Gestures

In 1900, Swindon became a borough, but the local authority continued to work from the impressive town hall building, which featured a clock tower some 90 feet high. The 'hand gestures' railings, made by artist and blacksmith Avril Wilson, were added to the front in 1997. The local authority relocated to the Civic Offices when they opened in Euclid Street in 1938.

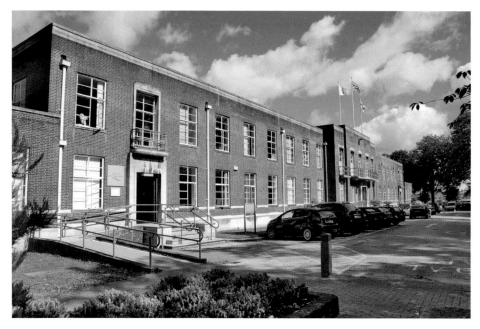

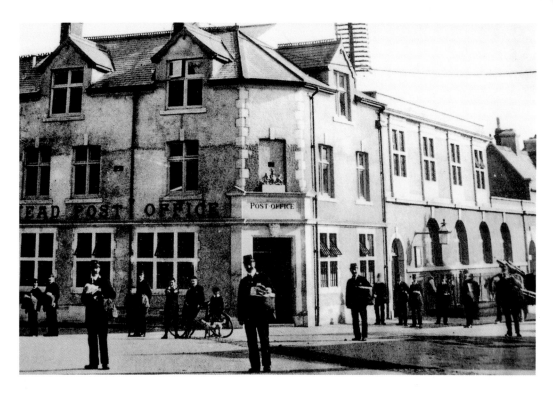

Opening Letters

In the 1820s, Charles Rose opened a letter office in part of the public bar at the Bell Hotel in High Street, Old Swindon, and whichever of his employees was free at the time had to deal with the mail. The system was on a much more formal footing by the time New Swindon's head post office opened in Regent Circus, on the corner with Princes Street, in 1901.

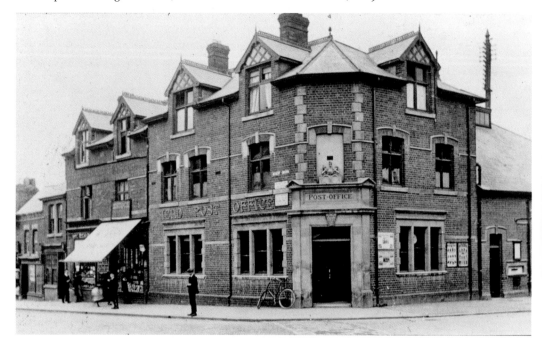

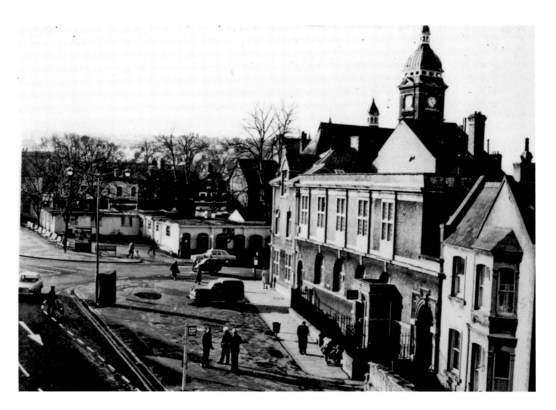

Postal Orders

The first postmaster in the Regent Circus head office was Henry Durden, although his sorting office was nearly a mile away beside the town's railway station. There it remained until the Regent Circus property was remodelled and extended in 1935. In 1964, the head post office relocated to custom-built accommodation elsewhere; the Regent Circus building was demolished in 1972, and a mixed-use rectangle was built on the site.

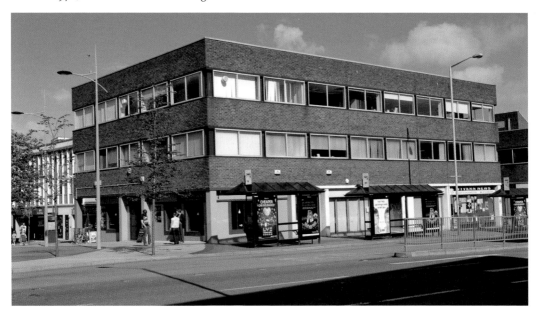

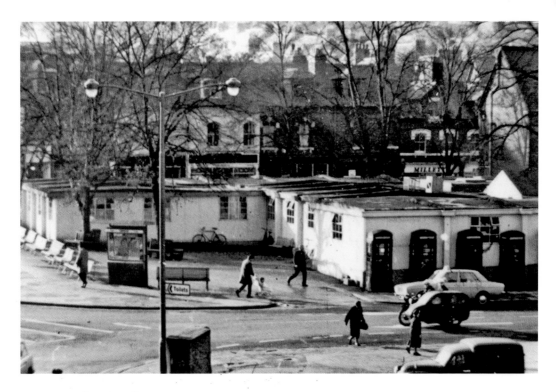

Temporary for Sixty-five Years

Swindon's first public library opened in 1943, in the corner of a department store; six years later, it relocated to 'temporary' prefabricated buildings beside the town hall. In 1976, these were pulled down and replaced by more of the same. The town's multi-award-winning, four-storey library building, designed by architects Nic Newland and Tony Currivan, opened on the same site in 2008.

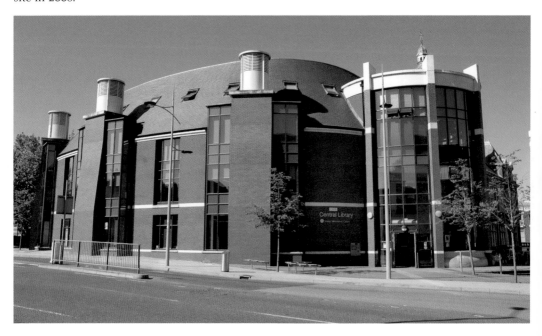

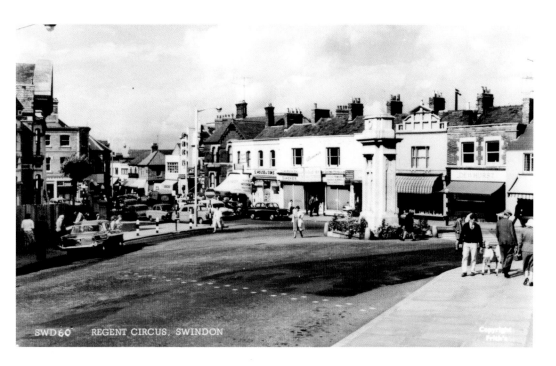

For the Fallen

Swindon's first memorial to its First World War fallen was a local-authority-funded wooden cross. Then, in 1916, local carpenter George Bathe made a wooden obelisk, primarily as his personal memorial to his dead son. Eventually, sufficient funds were raised by public subscription, supported by the *Evening Advertiser*'s 'shilling fund', to commission the cenotaph, made of Portland stone and set up in 1920 in Regent Circus.

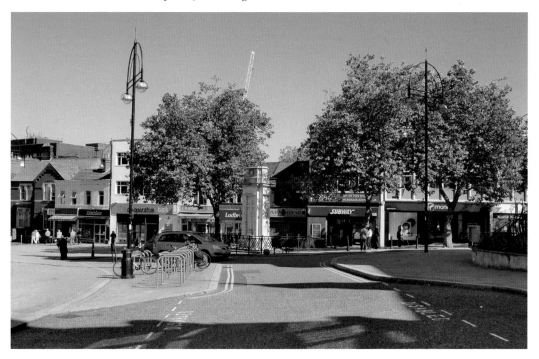

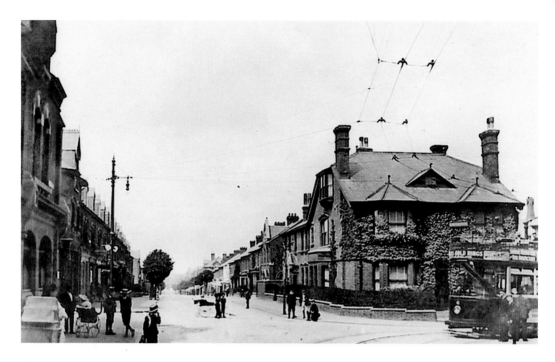

Fine Vines

Regent Circus had just been given its name and Commercial Road was hardly a decade old when this Edwardian villa was built where the two met. Number 34 Regent Circus was one of the finest residences ever built in New Swindon; it faced the town hall and spent most of its life clad in creeper. It was demolished in 1964, and the site is now occupied by offices and commerce.

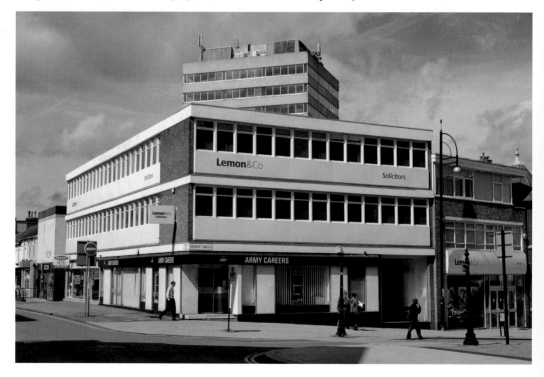

Changes of Use

During 1888 and 1889, rows of houses and shops were built on each side of the road between the New Queen's Theatre at the foot of New Road (Victoria Road) and York Square (Regent Circus). Eventually, these were all converted to retail. Today, this run is partly occupied by nightclubs, fast-food outlets, and ethnic cuisine.

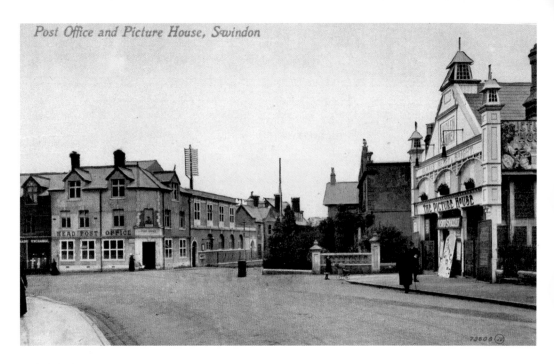

Post Office and Picture House, Swindon

Faded Flickers

The Picture House, Swindon's first indoor cinema, opened in Regent Circus in 1910, in premises previously used by an insurance broker and a Sunday school. It was renamed The Ideal Picture House in 1913, but closed soon after and became a motor repair shop, then a bus office, and then a florist's shop. In 1929, the custom-built Regent cinema opened next door.

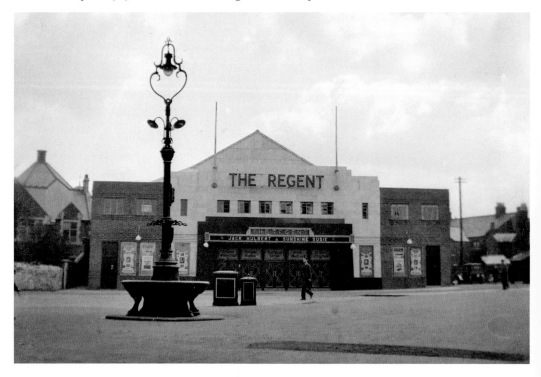

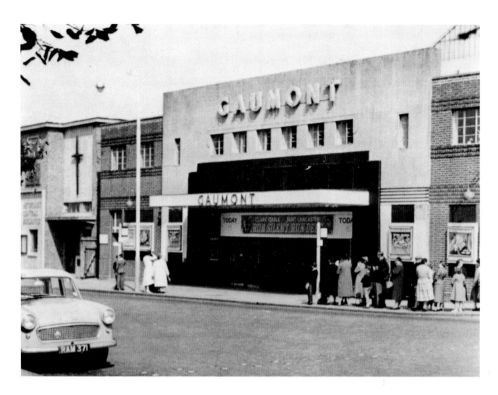

Silver Screens

In the 1950s, the Regent, owned by the J. Arthur Rank organisation, had its name changed to Gaumont. From 1962, it was called the Odeon. It closed in 1974, became a bingo hall and then a Top Rank Club, closing again in 2008. The premises were sold by Mecca to Swindon Borough Council. It was subsequently refurbished and reopened in 2010 as the Music Entertainment Cultural Arena.

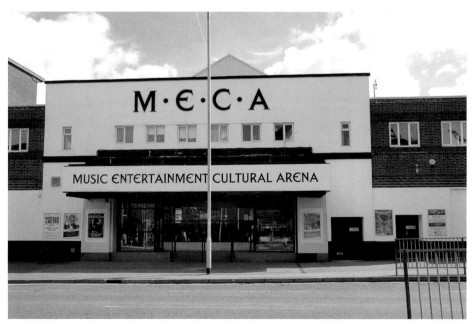

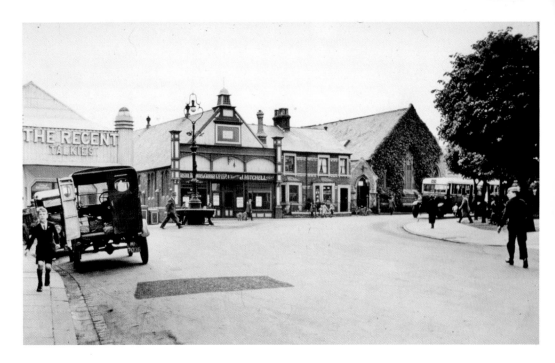

A Mixed Use Affair

The west side of Regent Circus in the 1930s: 'talkies' at the Regent; the Bristol Tramways & Carriage Company's offices in the one-time Picture House next door; and the Free Christian church building of 1875 in Decorated style, a Roman Catholic church (1882–1905), now creeper clad. It housed Swindon's first museum collection to be publicly displayed, 1920–30. The adjacent house was built in 1879.

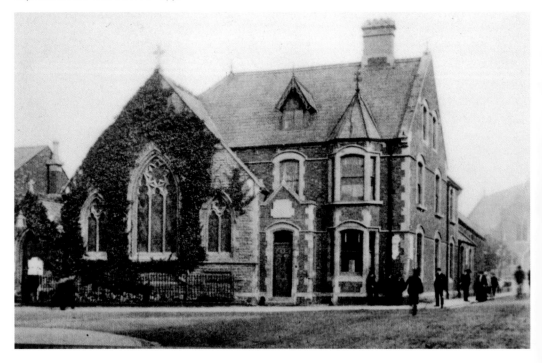

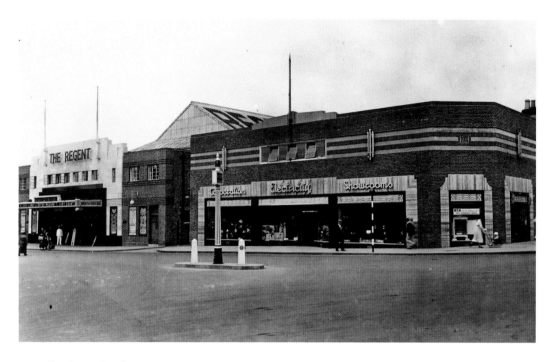

Art Deco Survivor

The former church (later museum) building and the houses that flanked it were replaced in 1933 by the Art Deco Swindon Corporation electricity showrooms. These premises later became a furniture shop, and a café took over in the 1950s. It has since remained in the restaurant and bar business, and still has its original 1930s lift in full working order.

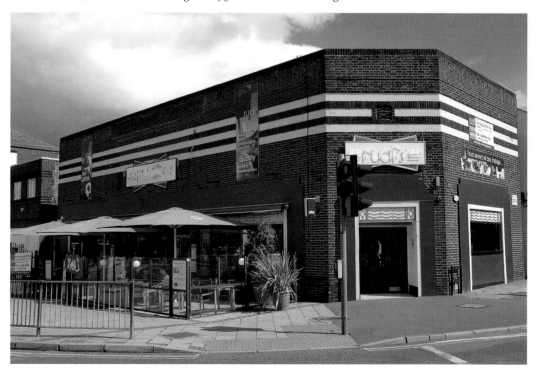

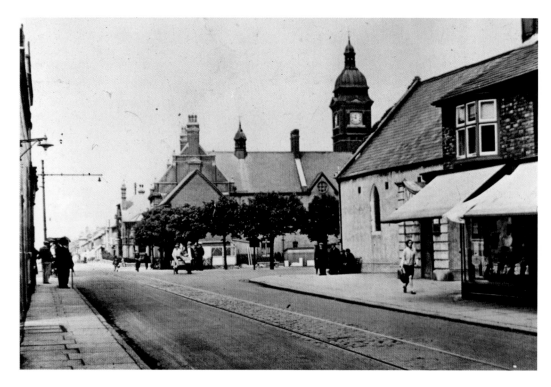

An Unfinished Picture

This picture from the late 1920s shows the rear of the town hall, which was never completed in accordance with the original design. Sheds litter the space where the town's central library would be built two decades later. It also shows the hall with its lancet window, then in use as the town's museum, and tramlines still in place around Regent Circus.

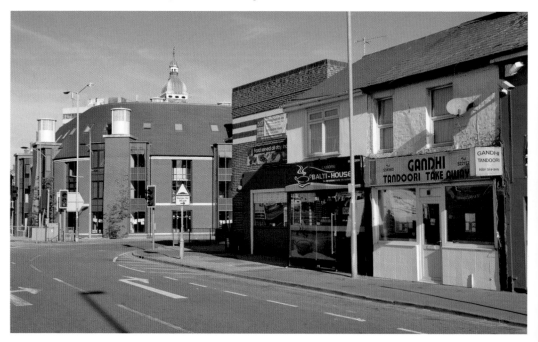

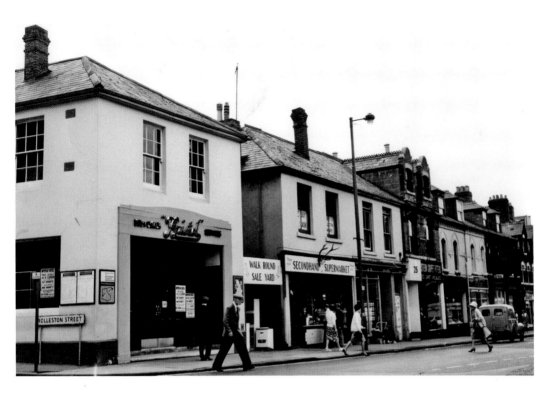

The Bus Office

The Bristol Tramways & Carriage Company moved from the west side of Regent Circus to the south side, and became the Bristol Omnibus Company. It occupied the Rolleston Street end of a terrace of shops until 1967, and its bus terminus was in front of them. Here, at one time, were Harold Fleming's sports shop and Nash's confectioner's. Modern commercial premises now dominate.

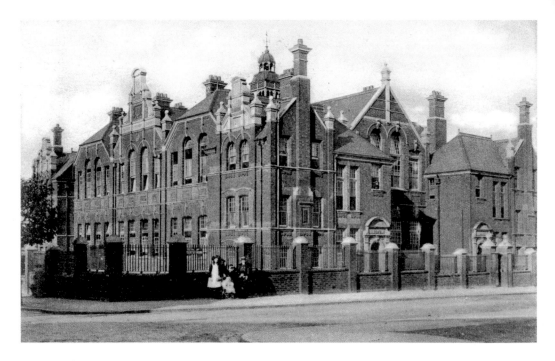

The Progress of Boys and Girls

Clarence Street School is now Grade II listed, and is used as local authority offices. It was built on the corner with Euclid Street in 1897, taking infants and juniors. From 1904, it had separate entrances for boys and girls, and it became a junior mixed school in 1946, afterwards taking children from the council estates on Swindon's eastern periphery. It closed in the 1980s.

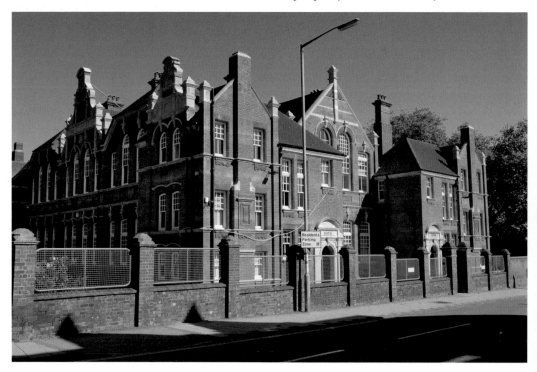

Sober in Red Brick

The Regent Hall stood, 1899–1967, just off Regent Street, and was largely designed, and the building project managed, by Swindon photographer William Hooper. It was a centre for evangelical nonconformism. Just five years after the little hall was built by private funding, the impressive County Court buildings were erected in Clarence Street. Gabled in red brick and with prominent freestone dressings, they were intended to impress.

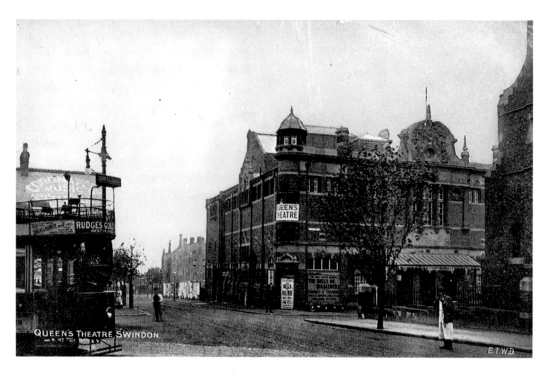

Theatre Comes to Swindon

The New Queen's Theatre, designed in Italian Renaissance style by R. Milverton Drake and John M. Pizey of Bristol for Ernest Carpenter, was built by Charles Williams of Regent Street, Swindon, in just thirty weeks. It opened on the corner of Clarence Street and Groundwell Road in 1898, and could accommodate an audience of 1,600 people. The first picture shows it in October 1904.

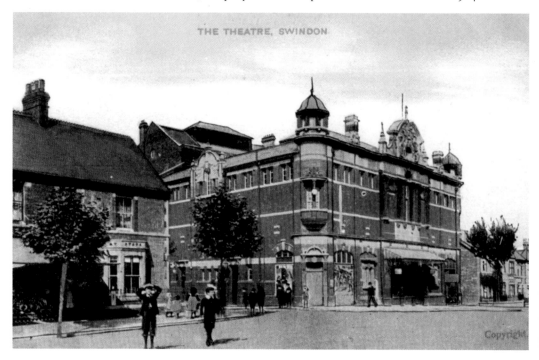

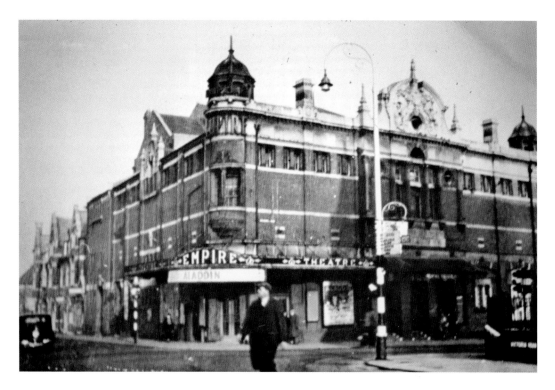

Entertaining Trends

The New Queen's became the Queen's and, from 1906, the Empire Theatre. Victorian and Edwardian melodramas gradually gave way to musical theatre and comedies, but it could not compete with the town's picture houses. Apart from pantomimes, occasional stage productions, and a year of stage shows in 1937, it operated as a cinema, 1930–47, after which it became a full-time variety theatre.

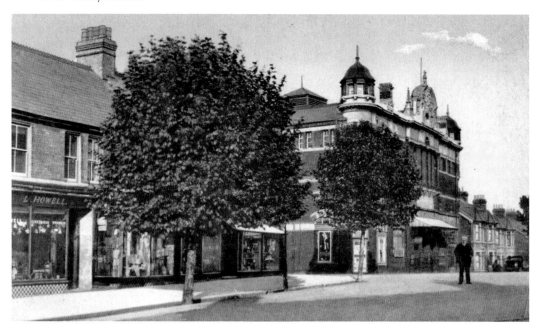

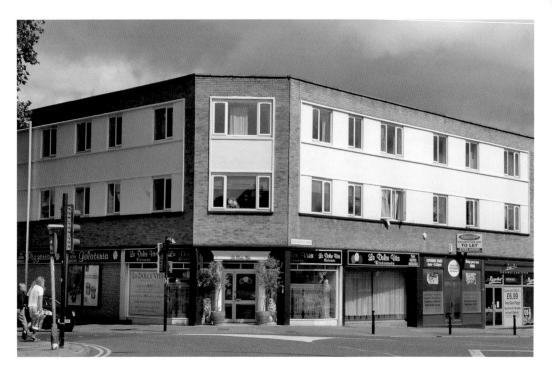

The Last Act

The Empire Theatre closed in 1955, between the end of a run of the pantomime *Robinson Crusoe* and the expected arrival of its successor, *Aladdin*. The building was demolished in 1959, and an office and retail block, named Empire House, was built on the site. Swindon was without a live professional theatre until 1971, when the 614-seat Wyvern opened a few hundred yards away.

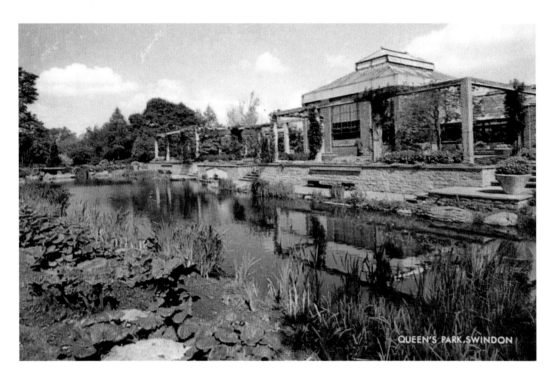

QUEEN'S PARK, SWINDON

Planting for Remembrance

In 1950 a rose garden of remembrance for the town's war dead was created out of clay pits, formerly part of the Drove Road brickworks. This was expanded into Queen's Park, designed by borough architect J. Loring-Morgan and park superintendent Maurice J. Williams, and opened in 1953. By the 1960s, it had a hothouse full of tropical plants, which was demolished in the late 1980s.

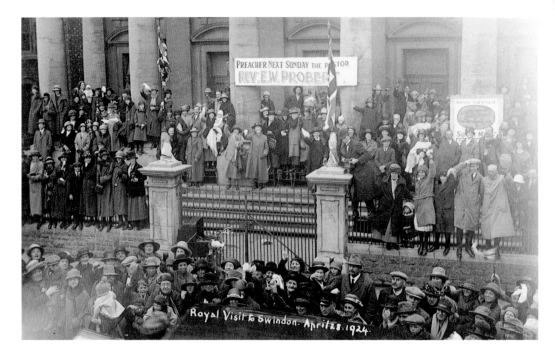

Stately Presence

The impressive, classical-style Baptist tabernacle, with its Tuscan colonnade and imposing pediment, was designed by Swindon architect William Henry Read. It was built of Bath stone, and was opened in 1886 at the York Place end of Regent Street. The flight of stone steps, running the whole width of the front, was a good vantage point when King George V and Queen Mary visited the town in 1924.

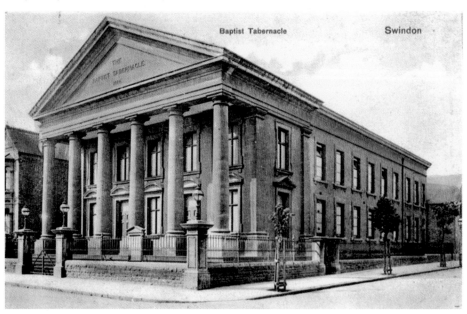

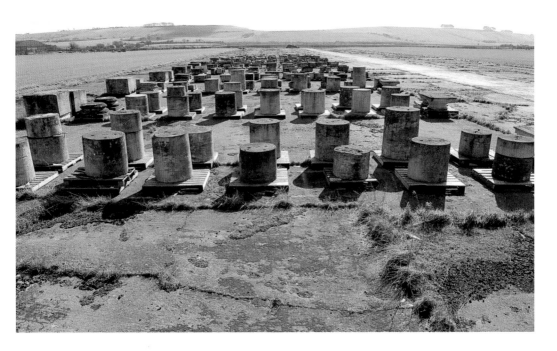

Pillars of Wisdom

The Baptist tabernacle was demolished in 1978, and parts of the fabric were sold on to owners who in turn failed to get planning permission to deal with them as they wished. In 2007, Swindon Corporation bought back what remained of the stonework, and has it stored on pallets pending future use. The Pilgrim Centre was opened in 1990 on the original site.

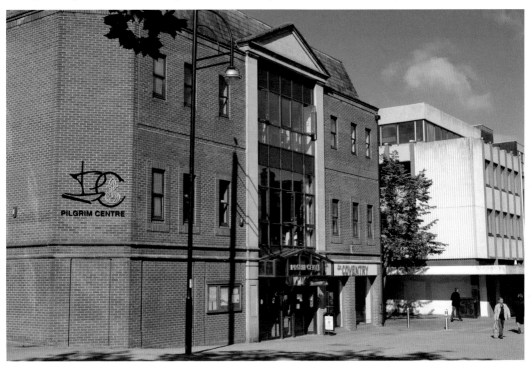

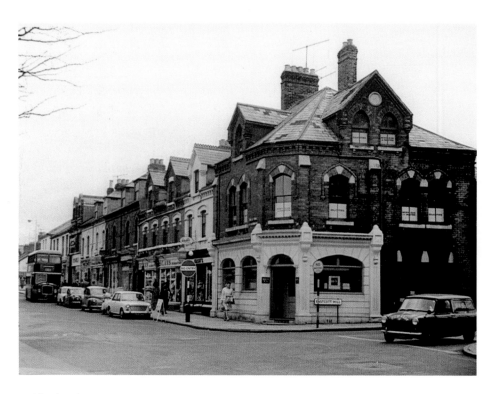

Gables by the Dozen

Regent Circus was developed in the angle formed where York Place, the eastern extension of Regent Street, met Rolleston Street. Its north and east sides were built up around 1850–80. This run of twelve shops and commercial premises was put up on the south side, around 1890, when New Road was opened up between Old and New Swindon. A modern commercial block is now in their place.

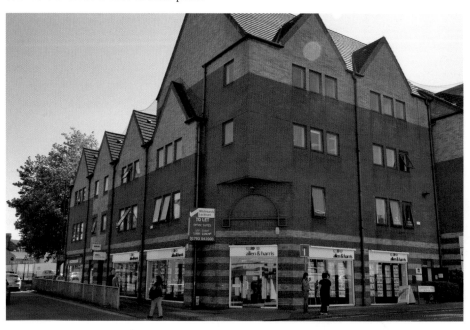

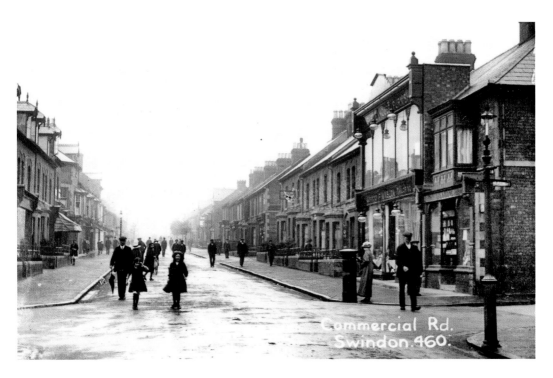

Commercial Rd. Swindon. 460.

Trade Roots

Commercial Road was built from 1888, six terraces of between nine and sixteen properties on each side. It was intended to be the town's main shopping centre, and although some independent traders went in, it remained mostly residential until the last two decades of the twentieth century, when most of the houses then remaining were bought up and converted to commercial use.

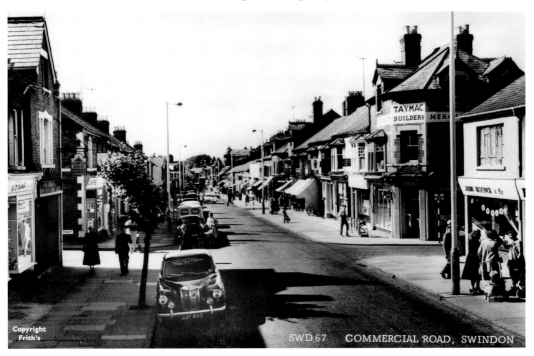

Copyright Frith's

SWD 67 COMMERCIAL ROAD, SWINDON

31

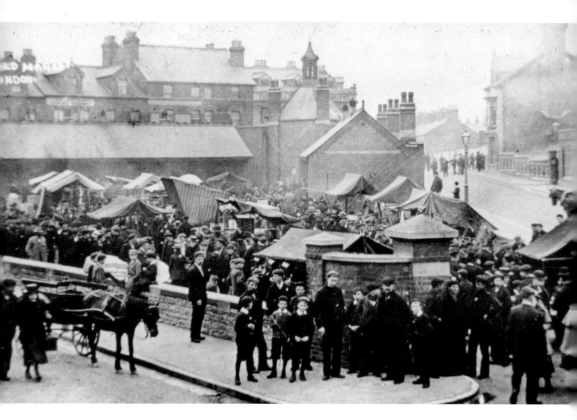

Raising the Roof

The outdoor market that opened in 1891, on a triangular site in Cromwell Street, was designed by local surveyor Henry Joseph Hamp. Within a year, it had acquired 'market shops, lock-up shops, and tent-like stalls'. The side walls were later built up in red brick with freestone dressings, the structure was roofed, and the indoor market opened in 1903.

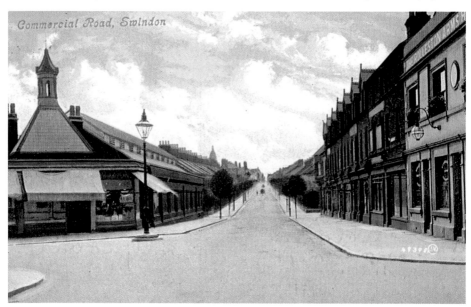

Commercial Road, Swindon

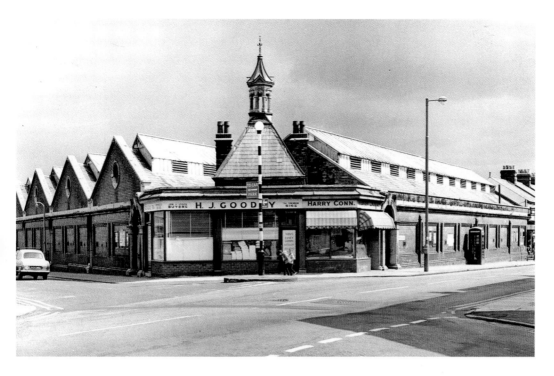

People in Glass Markets

By 1933, there were sixty stallholders and sixteen shops inside the market house, and a number of small traders had modest premises around its periphery. The building was demolished in 1977, and the site became a car park until 1995, when the glass and tented market house was erected, which is still in place.

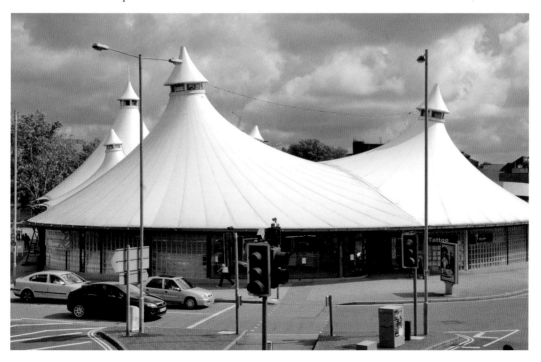

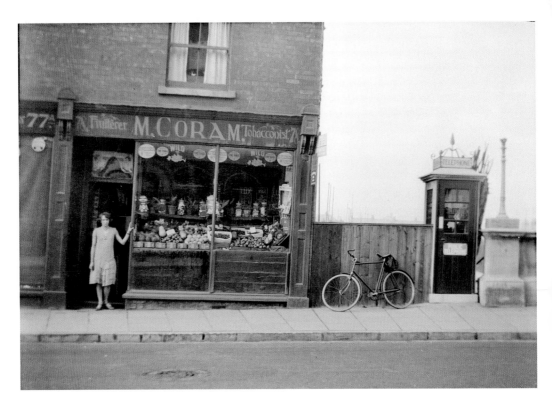

One Under the Eight

Designed by Edward Roberts, and built by Edward Streeter of Bath, using stone from the Swindon quarries and Bath stone dressings, the octagonal market opened beside the Mechanics' Institute in 1854. Eleven small traders had lock-ups there, and a beerhouse was attached. It was demolished in 1892. M. Coram, hard by Milton Road Bridge, was a small trader.

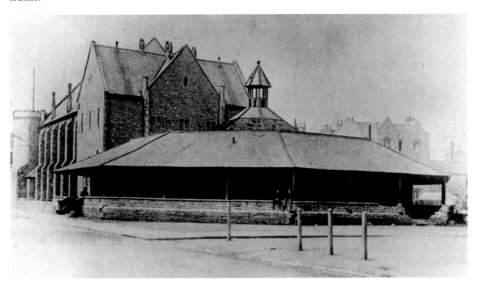

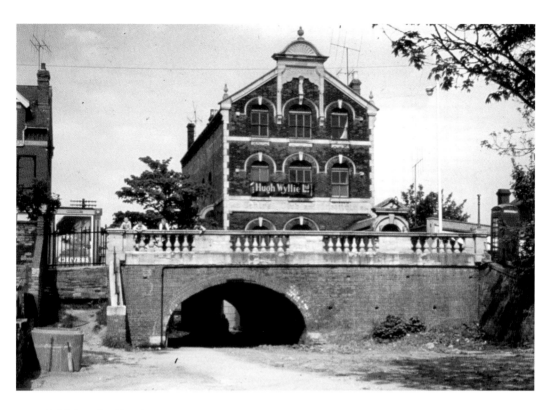

Bridging the Canal

Milton Road Bridge was built over the Wilts & Berks Canal in 1890. The Central Club & Institute that towered above, adjacent to Cromwell Street canal wharf, was designed by R. J. Beswick in Neo-Dutch renaissance style. It spent the 1960s and '70s as a discotheque, and was demolished in 1982. The route of the canal is a green walkway at this point.

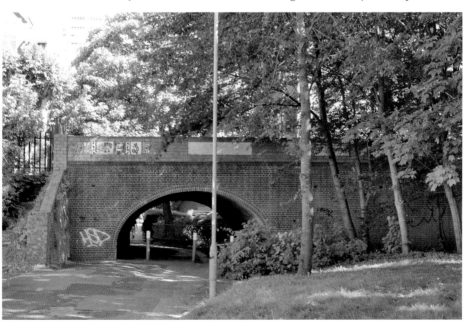

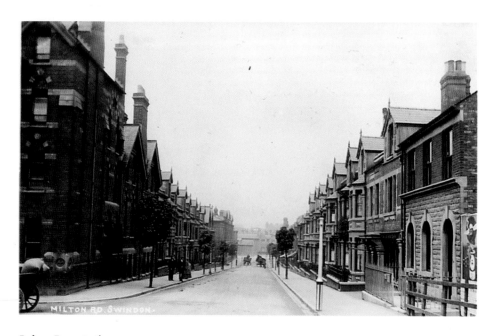

Below Expectations

Milton Road was conceived as a continuation of Commercial Road, which was expected to be the main shopping route (via what became Victoria Road) between the railway village in New Town and Old Swindon, and was laid out in the 1890s. It was almost wholly residential, and was separated from the traders of Commercial Road by the Wilts & Berks Canal.

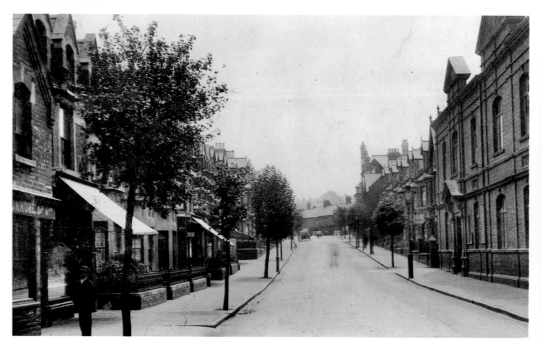

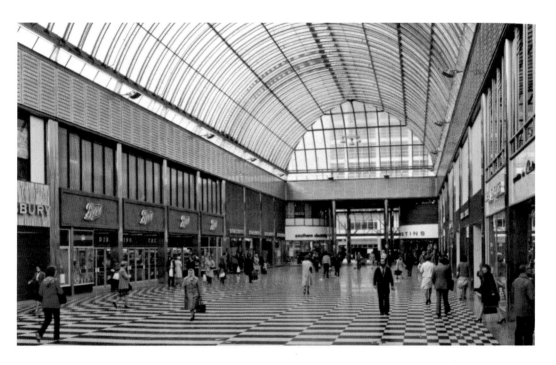

Escalating Fortunes

The Brunel Shopping Centre was built on the site of 126 residences, some retail premises, and several offices. The architects were Douglas Stephen & Partners. Building began in 1970 and the Centre opened in 1973; it was fully operational by the following year, but not finished until 1977. It was remodelled between 1995 and 1997.

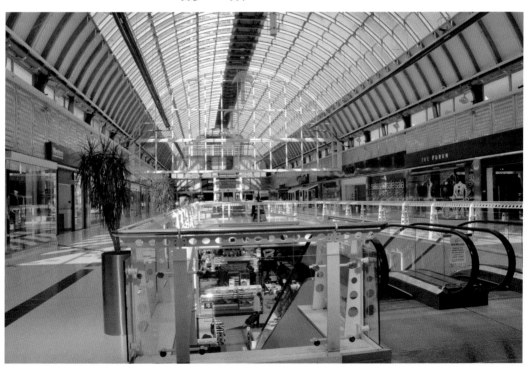

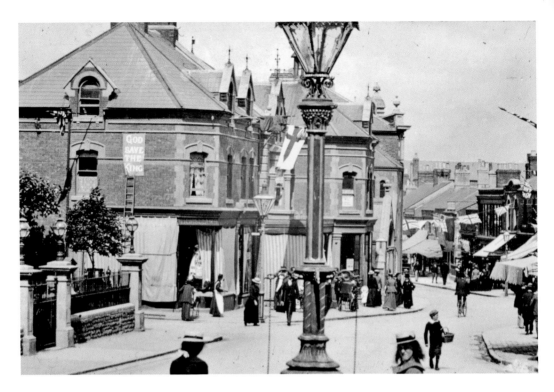

Praise for the People

The corner of Temple Street; built 1887/88, this link road between Commercial Road and Regent Street was so named because it provided access to the Baptist tabernacle, built in 1886. It also provided access to the nearby Primitive Methodist church in Regent Street, and to the Methodist schoolroom at its rear. The street was once lined with small shops; it now has multistorey office blocks.

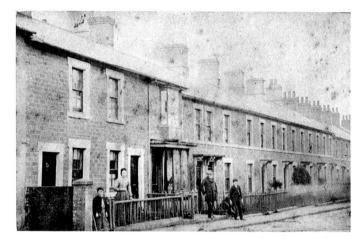

Humble Beginnings

Until about 1850, there were only some isolated cottages alongside the farm track that became Swindon's main shopping centre. The top picture, thought to have been taken around 1860, shows a terrace of small cottages with tiny, railed front gardens. They must have been recently built alongside the then unnamed thoroughfare, and were almost certainly at the eastern end, close to where Regent Circus is now. A few entrepreneurs put shop-style bow windows into their front rooms and set up in trade. By the 1870s, the street was lined with small terraces of one-up, one-down cottages, some modest detached properties, and a substantial number of shops. Waite's in Milton Road was an example of a small trader in a residential property that had been remodelled for retail.

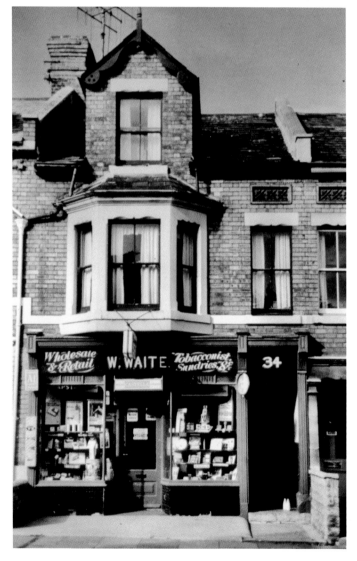

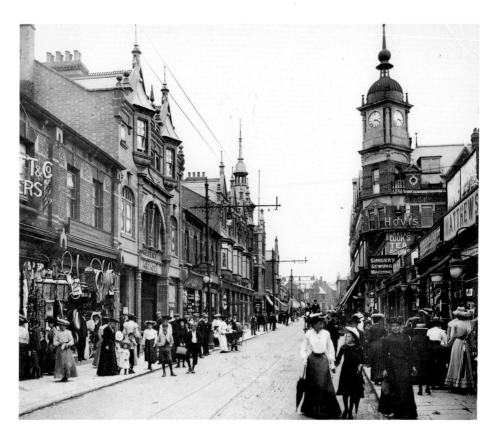

Not an Inch to Spare

By 1890, the whole of Regent Street had been transformed into the retail and commercial hub of New Swindon. A large number of terraced houses were converted to retail, custom-built shopfronts went in, and dedicated shop premises were put up where there were gaps between the terraces. Late Victorian traders packed their shop windows with goods for sale. Boys pose for the camera in the crowded scene from 1919.

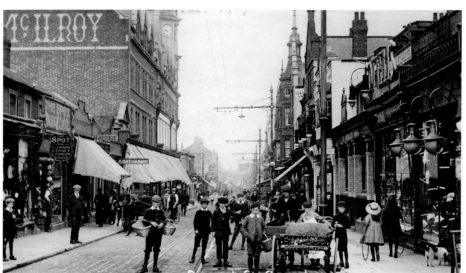

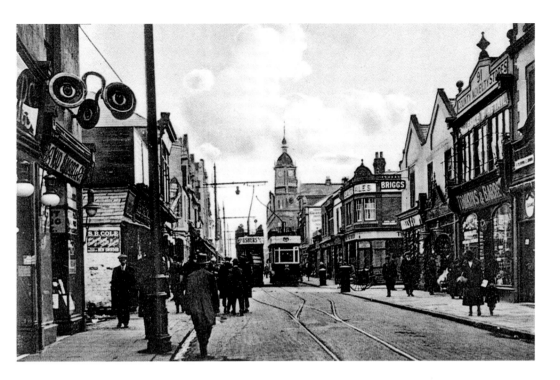

One Up, One Down

One tramcar is proceeding along Regent Street towards Old Town; the other is on its way to the tram centre in New Town. The crossing is outside the fine premises of Tomkins & Barrett, who established their wholesale 'County Novelty Stores' at 91 Regent Street in the 1880s, selling sweets, stationery, haberdashery, hardware, toys, and fancy goods. The spectacles belonged to optician David Smart.

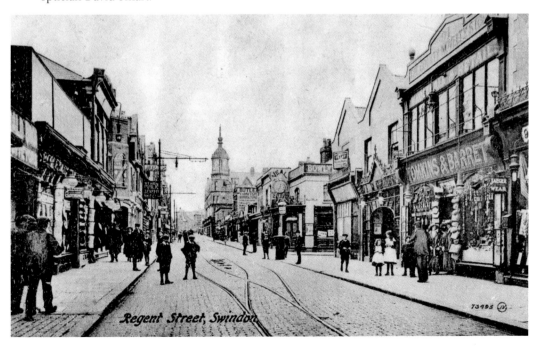

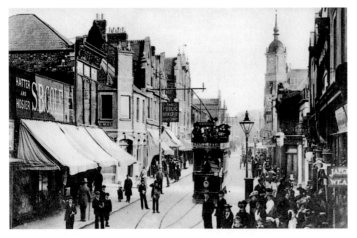

Moving Pictures

Two long-gone Regent Street public houses are here: The Eagle on the corner with College Street, and the Fox Tavern at Cromwell Street. The former existed for almost 100 years, being rebuilt as a single-storey bar area, and eventually closing in the late 1960s. The tramcar is advertising Samuel J. Limmex's Old Town hardware store. The Regent Arcade, a small mall of shops, gave its name to the Arcadia cinema, which opened in 1912 on the same site. It could seat 1,000 people, was the only Swindon cinema to be operated by a local company, and had its own orchestra. The children's matinees held there were called 'Penny Rushes'. The cinema went through several name changes, and at one time presented itself as an 'art house'. After a period as a bingo hall, it was demolished in 1974.

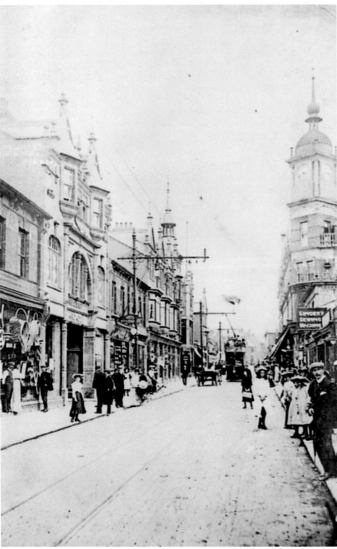

High Hats & Butter Paddles

Retail New Swindon set up in competition with Old Town on the hill, partly in its visual presence. Here, the clock tower of McIlroy's department store is mirrored to a lesser degree across the road in the spire of the corner turret that seems to go on and on, adding detail after detail. This run of late nineteenth-century buildings is visually as aspirational as retail premises in Swindon ever became – better than anything in Old Swindon and a joy to behold. Here were brick-built properties with freestone dressings and considerable architectural detailing. Look at the stilted shoulder gables with their pinnacles and ball finials, the little turret with its spirelet, all reaching for the sky in a display of ostentation. There are moulded strings and decorative brickwork between the gables; a moulded parapet that ties the whole run together by effectively continuing above the depressed window arches; and canted windows with ogee-shaped brackets. Plain awnings, and some with edging shaped like bunting, were part of the early street scene and many shops still had them in the 1950s. Several former traders are shown in these two pictures. Billett & Co. were hatters and hosiers, who opened in Swindon in the 1890s. Pearks grocer's began as Pearks, Gunston & Tee Limited, around 1900, in Market Street; they contracted the name in 1908 and are shown here at their shop, 76 Regent Street. They remained in the town until the late 1960s. The Halford Cycle & Motor Stores did not arrive next door at 77 Regent Street until about 1910, and Halfords is still in Swindon, although no longer in the centre. Singer's Sewing Machine Company opened in Regent Street in the late 1870s.

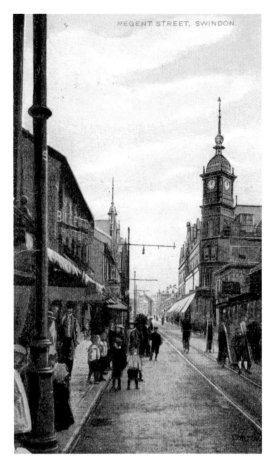

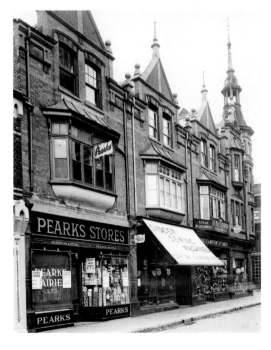

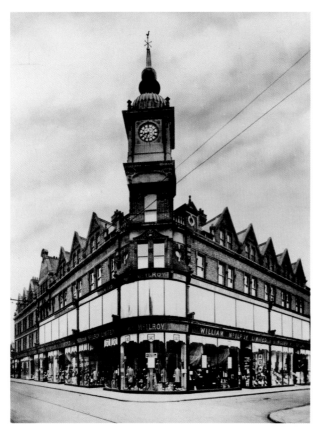

McIlroy's Time

William McIlroy was an Irish draper who had previously opened a store in Reading. His department store in Regent Street, Swindon, was designed by John Norman and built in 1875, after which its strapline 'The House For Everything' became well-known throughout the town. So too did its locally famous clock tower, perched on the diagonal, and which was added in 1904. The store was extended in 1902 and 1925, and the whole place was modernised and remodelled internally between 1957 and 1960, the year the clock was demolished as being unsafe. In the middle of all this, McIlroy's 'ballroom', an upstairs hall built on the Havelock Street side of the store, became the venue for the town's very successful traditional jazz club, and also for pop concerts. McIlroy's closed suddenly in 1998, and the site was redeveloped.

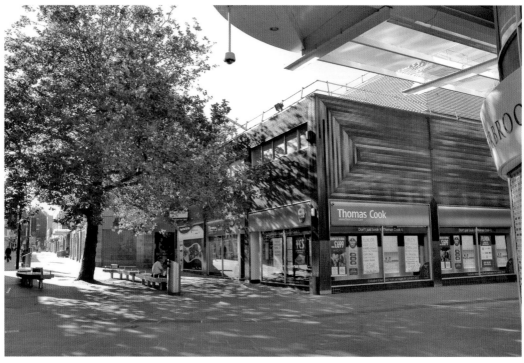

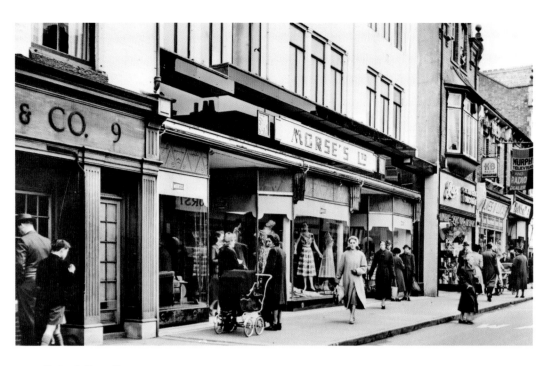

Duty & Devotions

Morse's department store (shown here in the 1950s) was the only significant competitor to McIlroy's in Swindon. The original owner, Levi Lapper Morse (1853–1913), was the son of a draper and grocer whose business was on Eastcott Hill. Morse was an ardent Methodist; the Regent Street Primitive Methodist church is shown on the left (below). It was demolished in 1957.

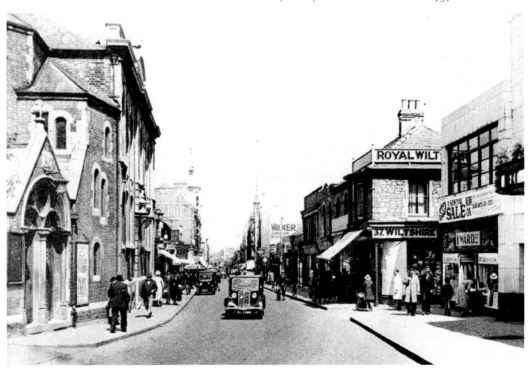

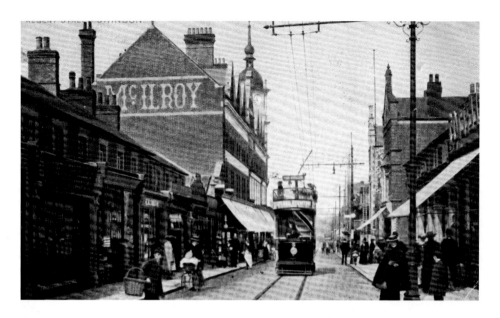

Upper Reaches

By the early twentieth century, many of Regent Street's original residential terraces had been converted to shops at street level. In the picture of around 1910, the upper-level façades are original, and it was still possible to see several intact as late as the '80s. The picture, below, taken from the same spot a century later, shows just a brief architectural nod to what went before.

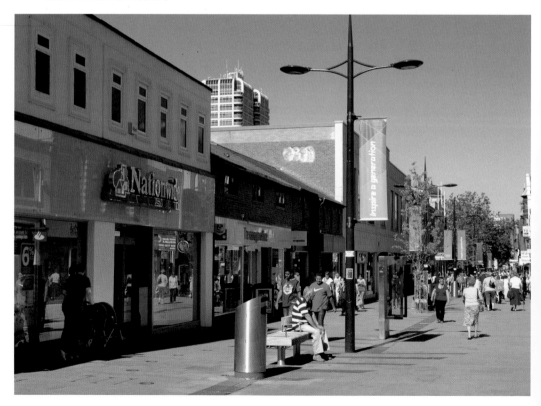

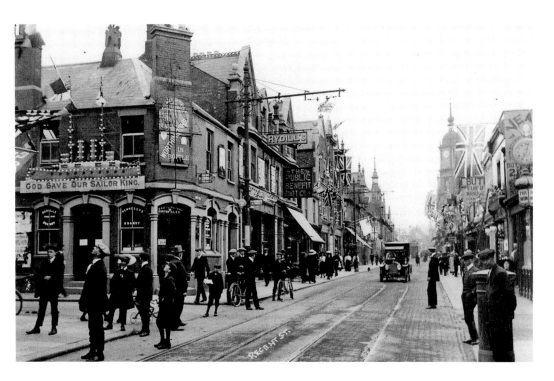

Dressed to Impress

The Eagle; dressed, as was Regent Street in general, for the Coronation of King George V in 1911. This beerhouse opened in the 1860s and took its name at the closure, in 1870, of an existing Eagle a little further up the road. It closed in the 1950s, and was remodelled and refitted as shop premises; the site was rebuilt into the characterless rectangle it is today.

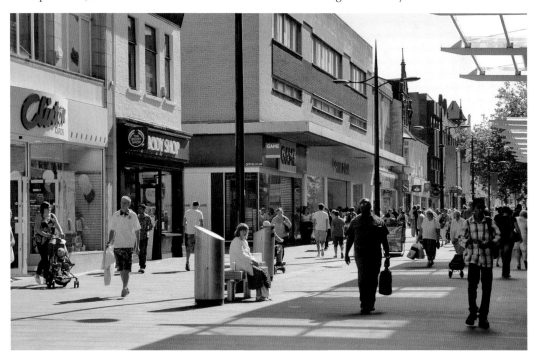

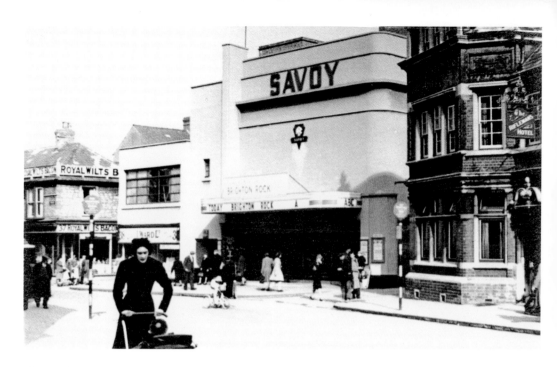

Linear View

The Art Deco Savoy cinema was designed by William Riddell Glen (1884–1950), and opened in Regent Street in 1937. It became the ABC (owned by Associated British Cinemas) in 1960, and was converted, in 1974, to a three-screen venue. The ABC was acquired by Cannon in 1986 and was so named from 1987; this closed in 1991, and since then it has been a theme bar.

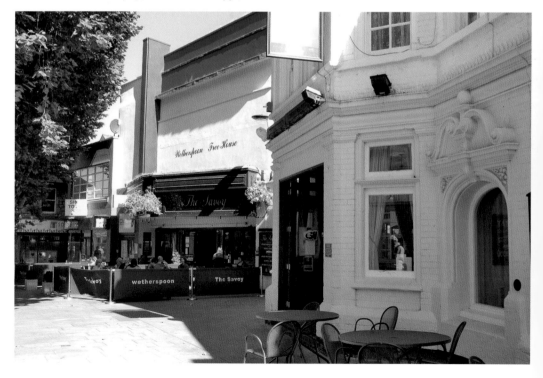

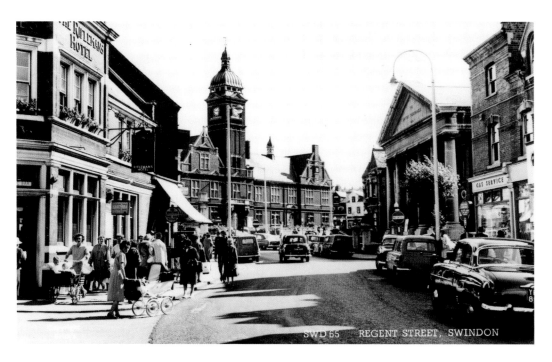

Foot Fall

Now you see it; now you don't. This view of Regent Circus from Regent Street includes the town hall, which remains, and the Baptist tabernacle that does not. The building that houses the gas office, the villas glimpsed next to the tabernacle, and the shops behind the town hall, have all disappeared. So have the vehicles, since the area was pedestrianised.

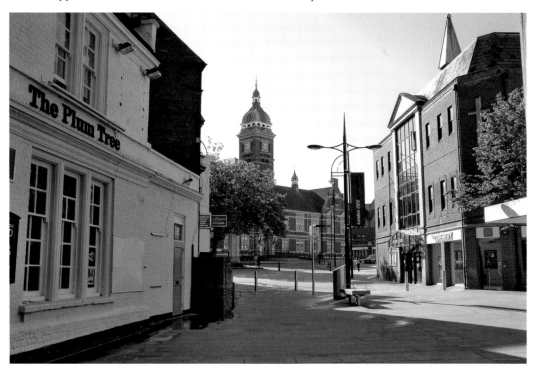

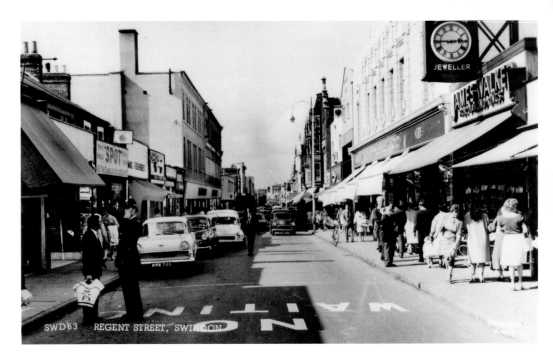

SWD 63 REGENT STREET, SWINDON

Almost a Century of Time

Not yet pedestrianised, but at least the traffic is only one-way (it had been two-way) along Regent Street in this picture from the 1960s. Woolworth's, which opened in Regent Street in 1913, closed in 2009. The premises next door has housed a watchmaker and jeweller since before the First World War.

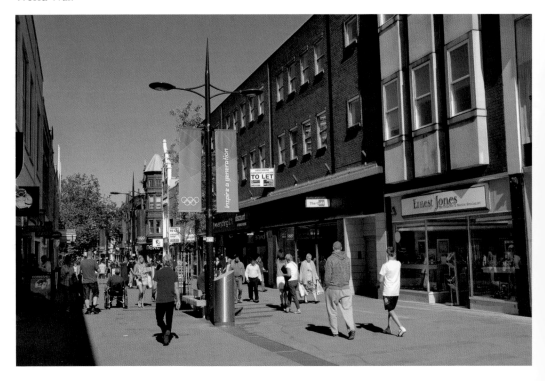

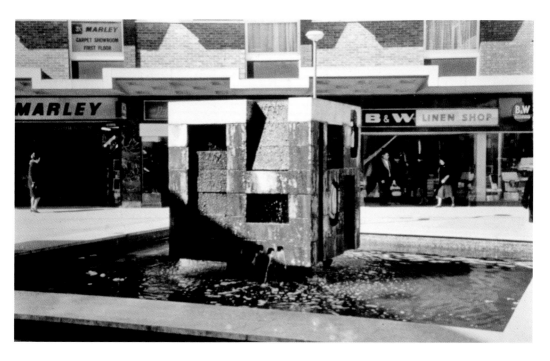

Cubism in Brief

The Cube, which was illuminated internally and dribbled pumped water from its orifices, was opened on the Parade in 1966 to almost total public condemnation. It was decommissioned in 1968, and quietly removed in the '70s. Walter Jack and Paul Channing's undulating *Crumpled Water Walls*, of ribbed steel and water, was erected in 2010 about 100 yards from the site of *The Cube*.

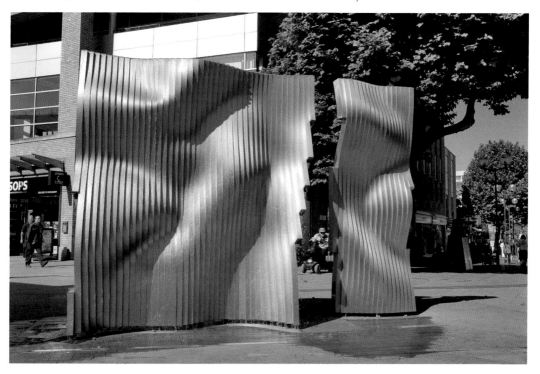

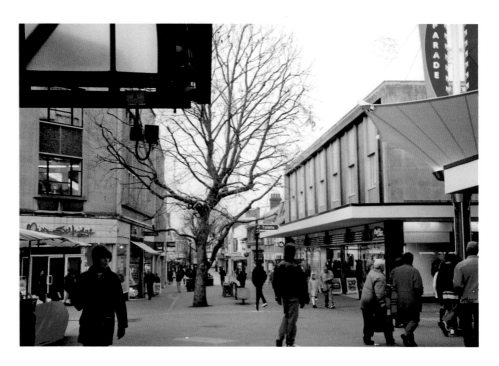

Green Room

The greening of central Swindon by strategically placed trees has become something of a *cause célèbre* in the last couple of decades. Hardly more than a sapling at the intersection of Bridge Street, Regent Street and the Parade when the picture above was taken, this tree has now grown to dwarf the several-storey buildings that have since been put up around it.

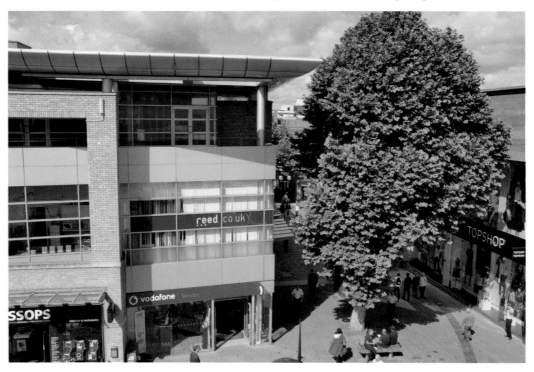

Mass Marketing

William Veal, watchmaker and jeweller, set up in 84 Regent Street around 1900; this picture, taken about a decade later, shows how well he was using his entire façade to advertise his business. Not only were his wares crammed into his windows, he advertised them across his upper storey in a way that drew potential customers' attention to how they might be used. William Veal's method of advertising was the equivalent of today's television shopping channels. It also suggested that the product was more important than the name. The photograph of James Walker's premises, from around 1945, shows a much more conservative approach to display, and how the brand name had become more visually important in the intervening years. There are fewer items on display in the windows, and they are presented in a way that facilitates much easier access for staff.

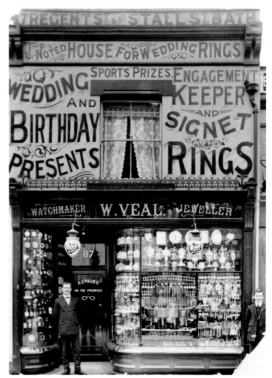

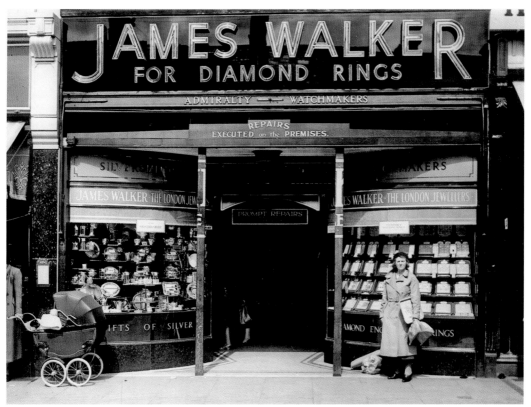

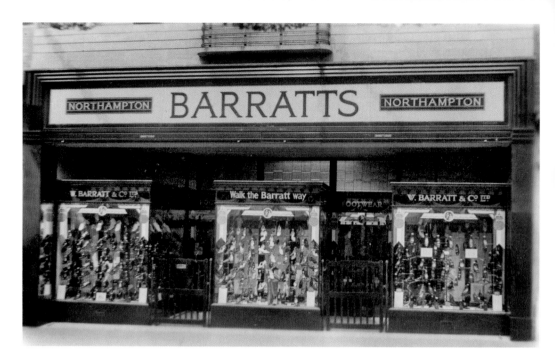

Spot On

William Barratt & Co., boot and shoemaker's, was established in 1903, and came to 21 Regent Street in the mid-1920s. The Spot, at 60 Regent Street, was a cycle and sports shop that also catered for model and toymakers. These pictures were taken around 1935 and 1945 respectively.

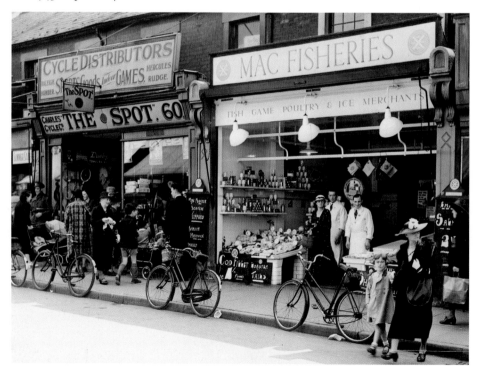

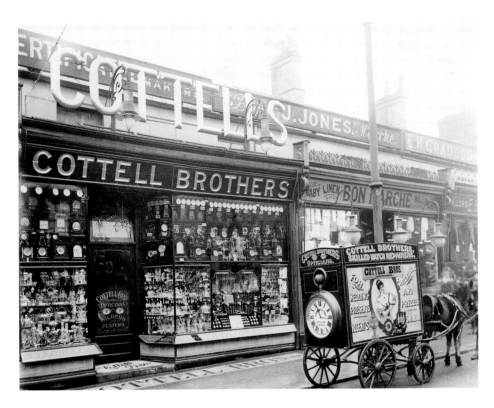

Butcher's Hook

The Cottell brothers were Charles (*b.* Bristol, 1870) and Frederick (b. Swindon, 1873), two watchmakers whose father was a railway clerk. By 1901, they were 'horologists', and they opened as jewellers and watchmakers at 26 Regent Street, just before the First World War. The same style of packed display is evident at F. Sparkes, butcher, of 47 Regent Street. Both pictures are from around 1910.

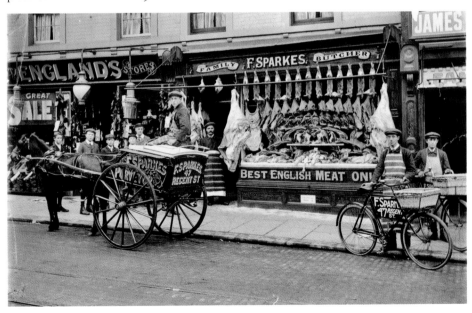

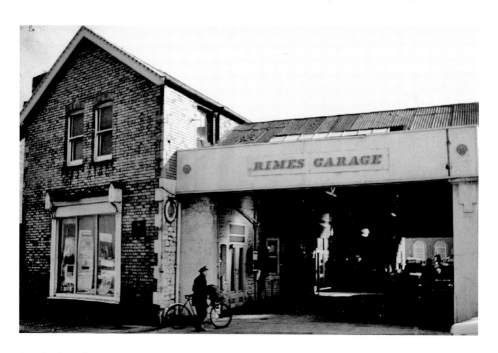

On the Benches

Albert Rimes's taxi company took over the premises of the Swindon Motor Charabanc Company at the Regent Circus end of Princes Street, where he developed his 'Central Garage'. The company added coaches in the 1940s. Rimes was sold out of the family in 1958, after which the Swindon premises was used only as offices. It ceased trading in 1988, and Kingsbridge Point now occupies part of the site.

Winning Counters

Marks & Spencer opened its London Penny Bazaar at 90 Regent Street in 1911, and continued to trade from there until 1931, when it acquired William Veal's former jeweller's shop at No. 87, which had latterly housed a furniture and upholstery business. Marks & Spencer built up an Art Deco three-bay, three-storey façade on this site. Next door was the Fox Tavern, one of several Regent Street public houses that developed out of mid-nineteenth-century beerhouses. It was a plain, low, two-storey building with round-headed upper windows until it was rebuilt in 1913, when the whole of the ground-floor elevation was coated in glazed tiles and decorated with inset panels. The Fox Tavern had been in business for about a century when it closed in 1963, and the site was acquired by Marks & Spencer. They extended their retail premises onto it in 1964.

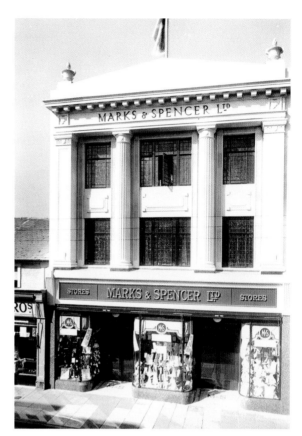

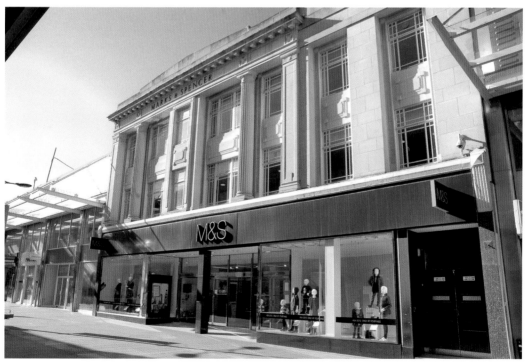

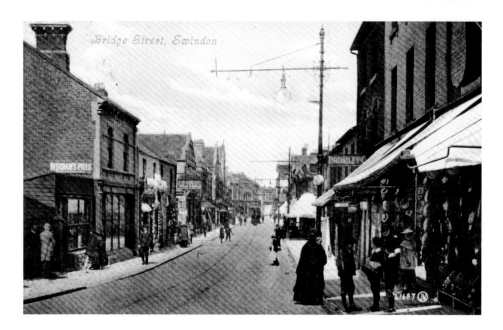

Symbol of Pride

Bridge Street, around 1905: Bromley and Co., ironmongers at No. 40, faced Keogh Brothers, glass and china dealers, across the road at No. 45. Just off the picture, to the left, is the Golden Lion Inn, built in 1845 beside the Wilts & Berks Canal. It was demolished in 1958, and the contemporary picture below shows the replica golden lion, the only reminder of it.

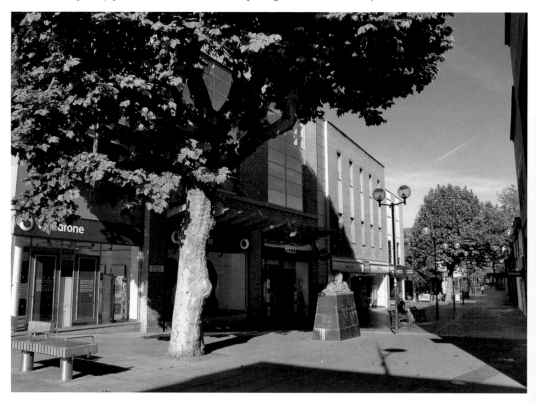

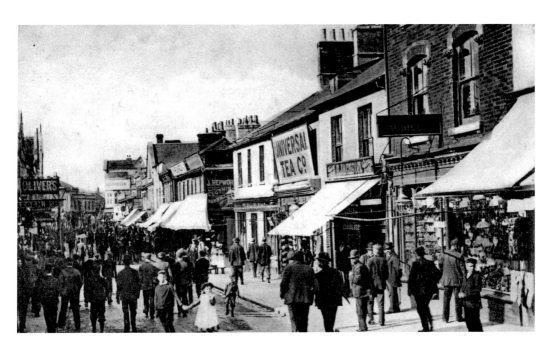

By Any Other Name

'GWR men returning to work' reads the caption. They are passing the Rolling Mills pub, formerly the Sir Charles Napier of the 1850s. It was renamed in 1861 in the hope of attracting men employed in the rail mills that had recently been established in the nearby Great Western Railway Company's Swindon Works. The picture below, from the opposite angle, shows larger buildings but fewer traders.

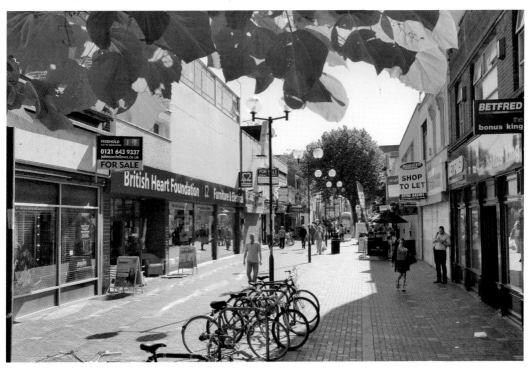

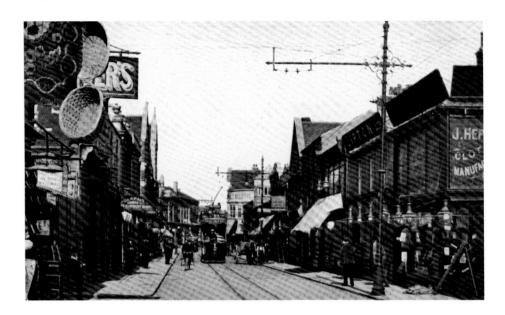

Time for Tea

Another contrast, though not quite so stark, shows Bridge Street around 1910. Charlotte & Annie Paul's Bridge Street Refreshment Rooms are evident close by George Oliver's boot and shoe shop (theme wine bars now occupy the spot). Across the road are Swindon stalwarts: Hepworth's tailor's and Lipton provision merchants. The 1930s picture shows Currys on a site it occupied for decades, close by the Lamb Inn.

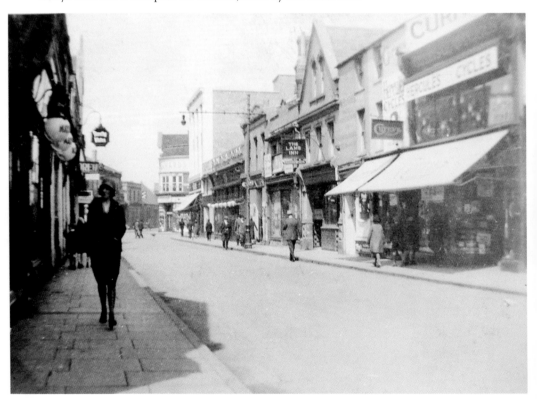

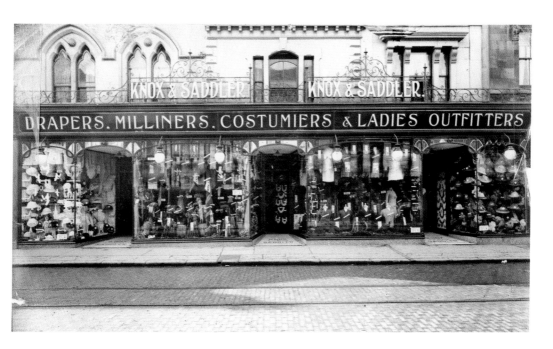

Full of Front

Knox & Saddler were drapers at 52–54 Bridge Street and John Drew, printer, stationer and bookseller, was at No. 51. These premises latterly became a branch of John Menzies. Both businesses were established in the town in the opening years of the twentieth century; these pictures were taken around 1910.

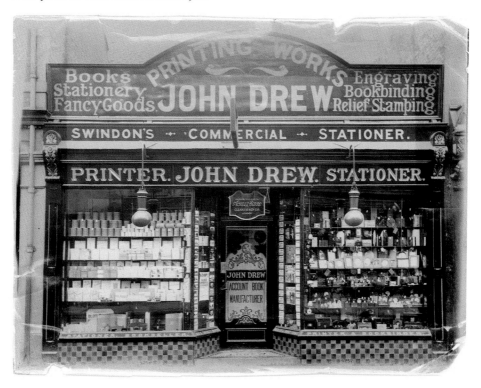

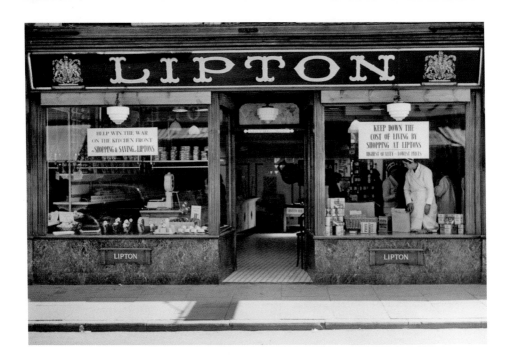

Stocking the Larders

Pictures of Bridge Street traders, taken in the mid-1940s. Lipton's grocer's at No. 35 is exhorting housewives to 'help win the war on the kitchen front' and 'keep down the cost of living by shopping at Lipton's'. Weaver to Wearer, the 30-shilling (for a suit) tailor, was also keeping down the prices. Keogh Brothers' shopfront and style of display had hardly changed in four decades.

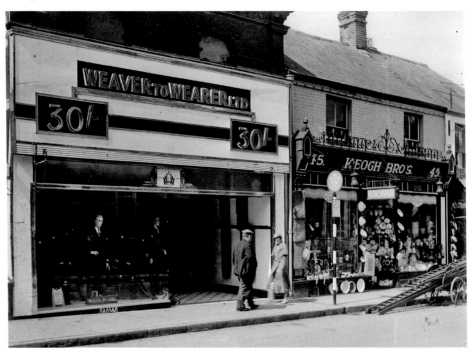

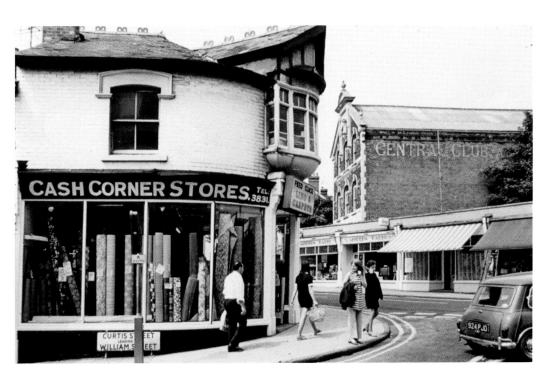

Market Links

Nothing in this photograph, taken in the 1950s, still exists. Fred Clack's lino and carpet Cash Corner Stores also once had a life as a second-hand bookshop. The run of single-storey shops opposite, here including the premises of Modern Radio, linked Milton Road with Market Street, via the Commercial Road market.

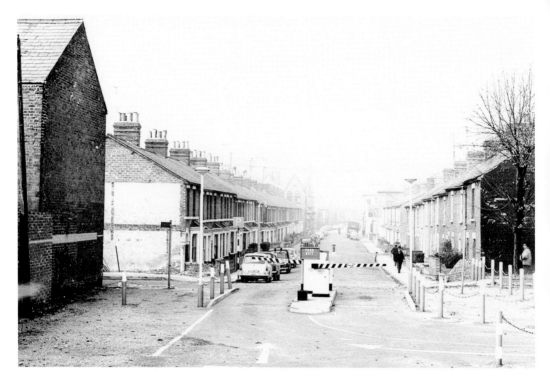

Coming Down and Going Up

Farnsby Street, built mostly in the 1880s, comprised the kind of red-brick terraces that epitomised domestic building in Swindon towards the end of the nineteenth century. The picture from 1964 shows the street in transition; everything was about to be swept away so that multistorey car parks could be built on the east side and multistorey office blocks to the west.

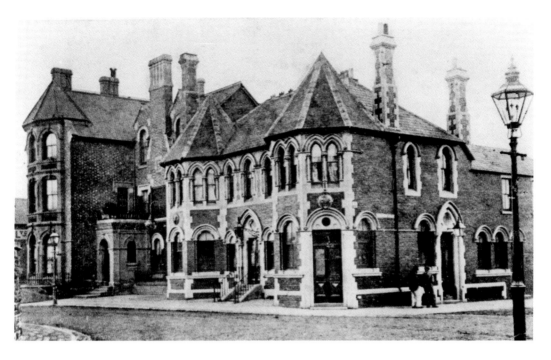

Wetting Whistles at Each End

The Great Western Hotel was built, 1870–71, opposite Swindon station to compete with the nearby Queen's Tap, the Queen's Royal Hotel on the station, and the Queen's Arms at the end of the road. At the other end of central Swindon, the Rifleman's Arms, dating from around 1852, was rebuilt in 1888 and has quite inexplicably been recently renamed the Plum Tree.

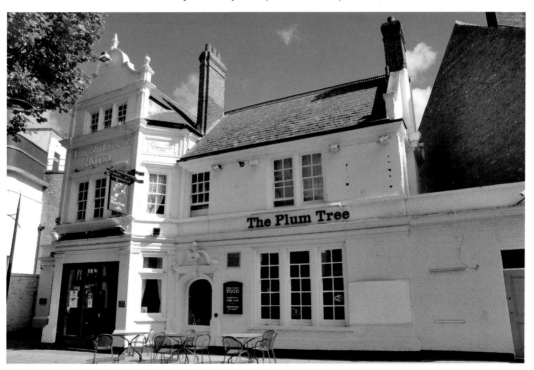

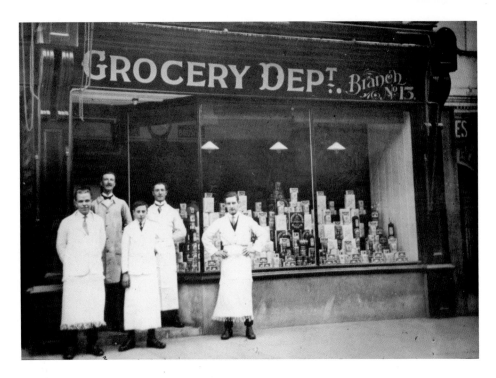

United We Stand

In 1850, a group of Swindon men introduced trade among themselves under the consumer co-operative system. In 1853, they registered as the Swindon Co-operative Provident Society Limited, principally as 'bakers and flour dealers'. In 1861, a breakaway group formed what became the New Swindon Industrial Co-operative Society, in order to increase the range of products sold. In 1880, they were joined by the Kingshill Co-operative Society.

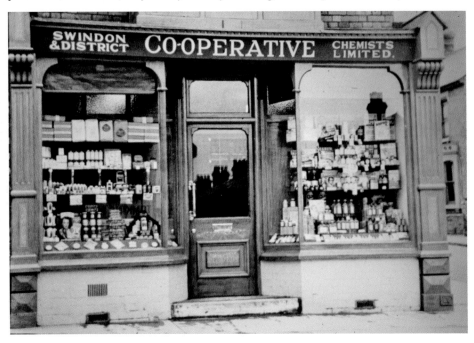

Pulling Together

The Swindon Co-operative remained true to its baking principles; the New Swindon went into the covered market beside the Mechanics' Institute, where it was eventually to have three stalls, and diversified into groceries, boots and shoes, and drapery. Even so, the co-operative ethic did not catch on at first in Swindon, and did not rally until the 1870s. The two early Societies went into premises in East Place (later named East Street), and gradually opened shops all around the town. The Swindon Co-operative stopped trading in 1951, and the Kingshill Co-operative followed two years later. Just one organisation was left, now named Swindon & District Co-operative Society. This merged with its Oxford counterpart in 1969 to become the Oxford & Swindon. It eventually added Gloucester and then merged with the West Midlands Co-operative Society in 2005, to become part of Midcounties Co-operative Limited.

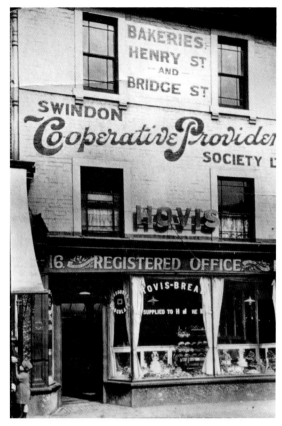

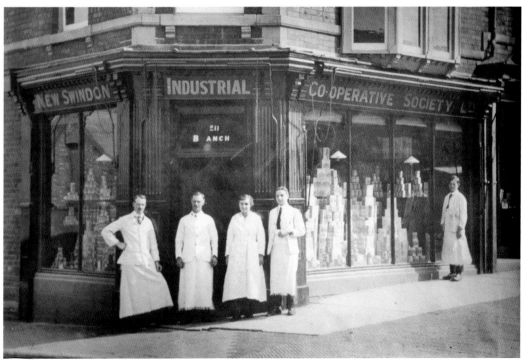

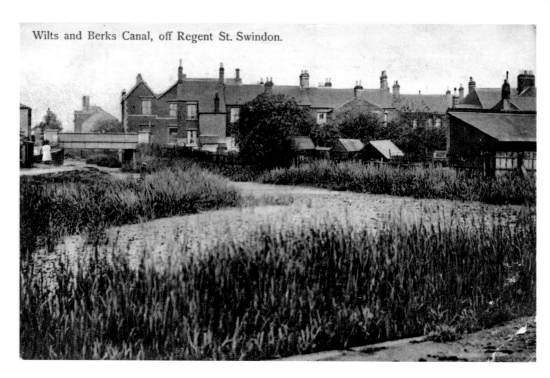

Wilts and Berks Canal, off Regent St. Swindon.

The Power of Steam

The Wilts & Berks Canal reached Swindon in 1804. It prospered until the 1840s, after which the railways gradually acquired the canal's freight traffic. In 1875, the canal company sold it to a consortium of businessmen, but it did not revive and was closed down in 1914. Its former course runs through the centre of modern Swindon, here beneath the town's 'living wall'.

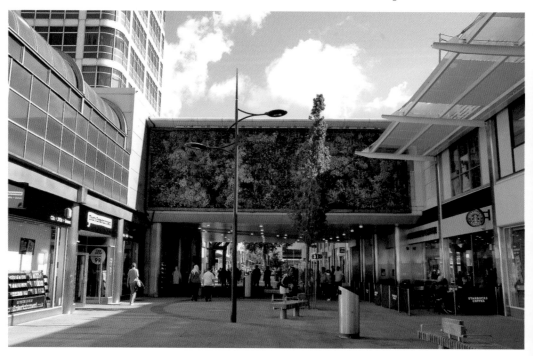

Different Lines

These pictures were taken from the same spot, just a few yards along Canal Walk from where the living wall is now. The original golden lion sculpture can be seen beside the pub on whose roof it once stood, but the houses alongside the path and the remains of the gasworks towards which it led have all fallen to the onslaught of consumer Swindon.

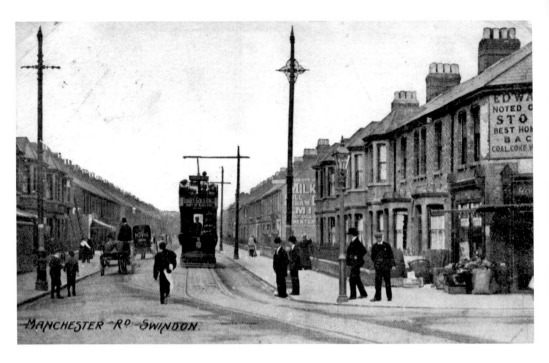

Out on a Limb

Manchester Road began close to the centre of Swindon in 1870, when it was called Mill Street. It became the main route between Swindon station and the County Ground complex after the latter was opened in 1893. Even so, seven years later there were still only fifty-six properties in the street.

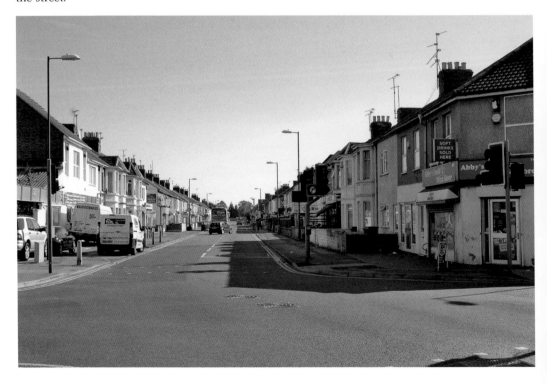

Community Centre

Despite its proximity to central Swindon, the Mill Street/Manchester Road community was always fairly self-sufficient. Corner shops appeared, and others spread along it as the road was built up. Most of the early retail premises are still used as such, and it is today a lively centre of trade in what has become an multicultural area of the town.

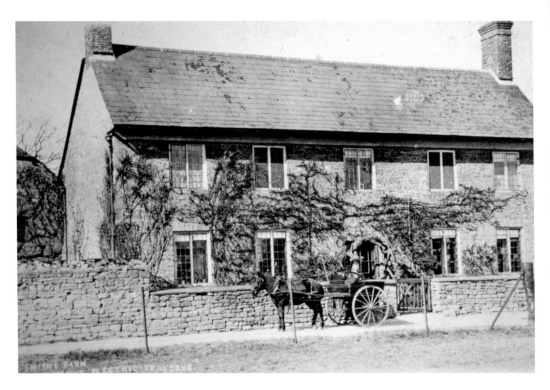

Let There Be Light
The Swindon New Town Electric Lighting Order, 1895, brought electricity to Swindon. The Swindon Corporation Tramways & Electricity Bill, 1901, consolidated the two services. The electricity works, with its 150-foot chimney and giant cooling tower, built on the site of Lower Eastcott Farm to facilitate both utilities, was opened in 1903.

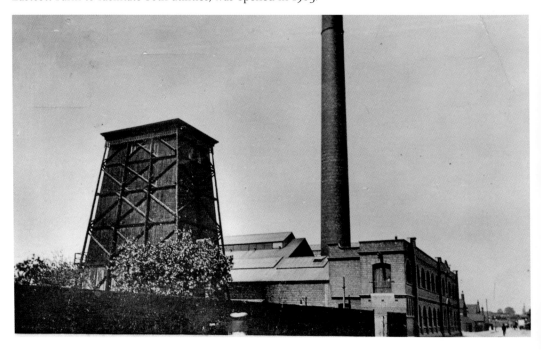

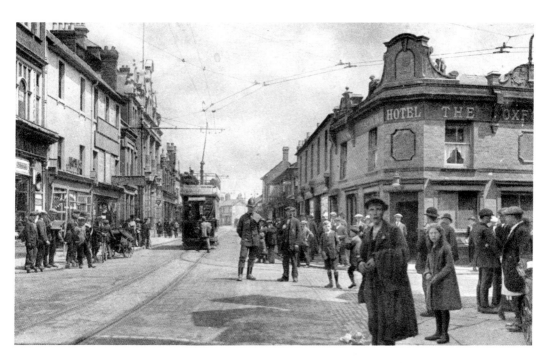

Suited and Booted

This view photographed around 1912, eastwards along Fleet Street from the tram centre, shows the Oxford Hotel; the name had been changed that year after four decades as the Volunteer. It closed in 1929; Burton's the tailor built an Art Deco shop on the site, and it had several other retail uses before being converted variously to a nightclub, a theme bar and a town-centre public house.

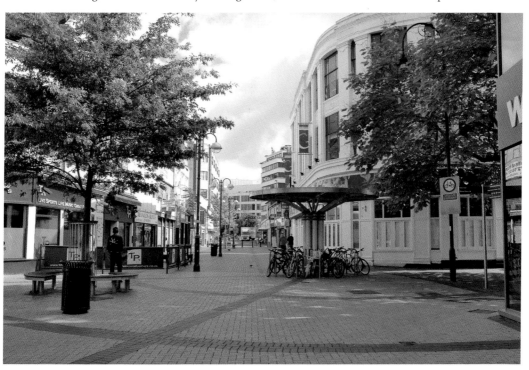

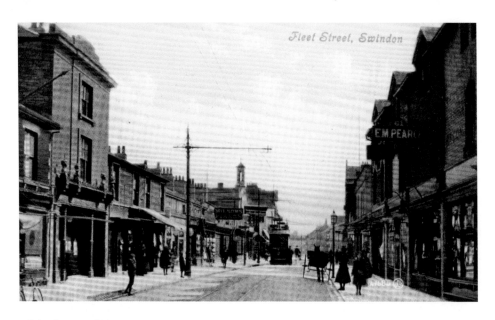

All in the Retail

This view, photographed eastwards along Fleet Street towards the tram centre, shows that every building included shop premises at street level. This was the area into which retail was first shoehorned when the nearby railway village outgrew its own shopping facilities, just before the potential for trade in Regent Street was properly explored. Today, it is less dense and is a mixture of small traders, food and leisure, and bar culture.

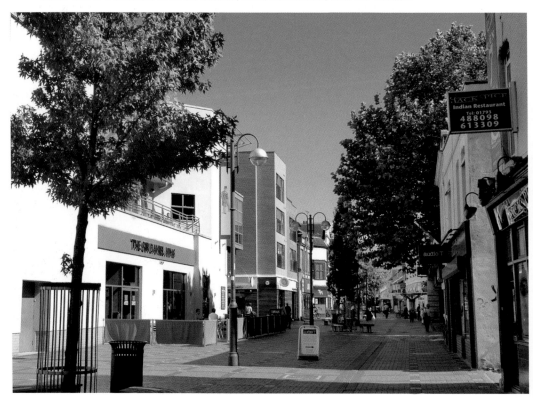

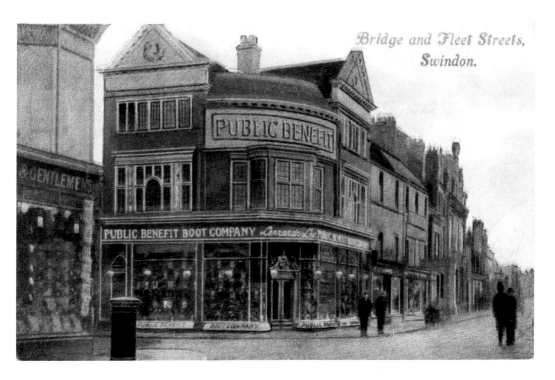

Sole Business

The Public Benefit Boot Company set up in Regent Circus in 1895, had opened premises in Wood Street, Old Town by 1898, and, around 1902, moved to this large premises on the corner of Bridge Street and Fleet Street. The buildings all around this property have been demolished or redeveloped, but this façade survives relatively unchanged.

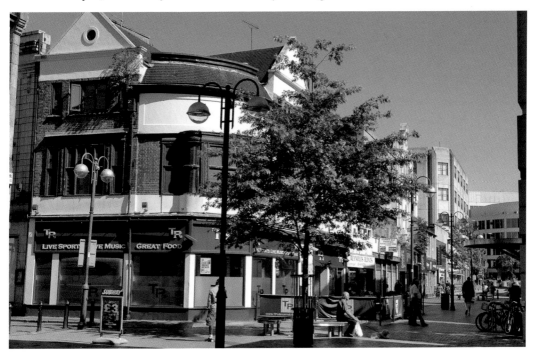

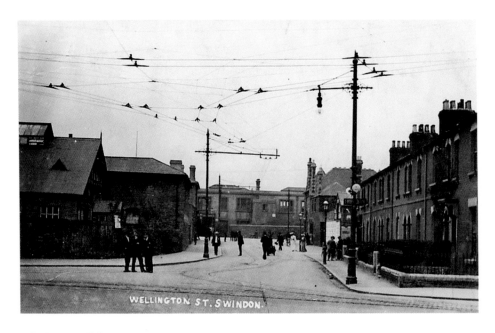

Mission Possible

Wellington Street once led from Fleet Street and Milford Street to Swindon station. Most of it was demolished when Swindon's bus station was created in 1967, and the station end was eventually redeveloped. The little wooden Railway Mission on Wellington Street was built in 1903 and destroyed by fire in 1979.

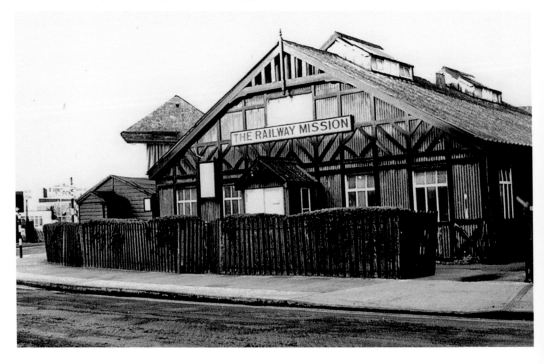

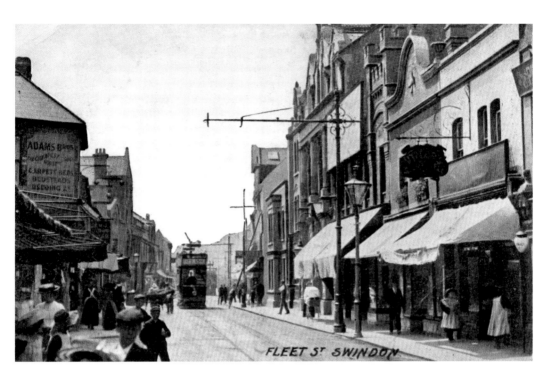

FLEET S⊤ SWINDON

Beef Burgher

This view, looking west along Fleet Street towards the tram centre, covers the same area as on page 73, but from the opposite direction. It shows some fine buildings. One of the traders there, pictured at about the same time, was Henry Bailey, who styled himself 'the people's butcher' and must have been sure of a roaring trade.

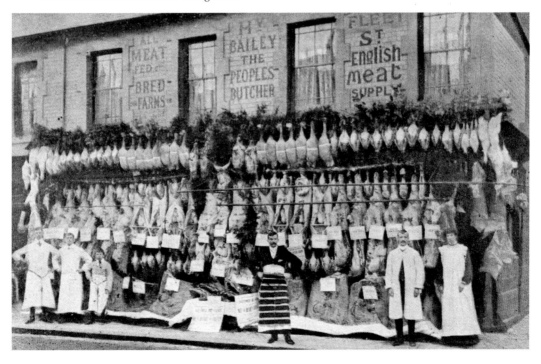

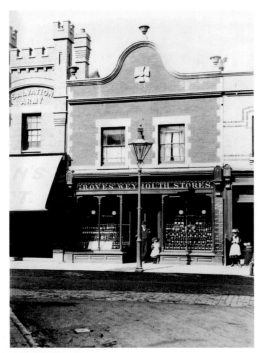

The Good Fight

The Salvation Army were probably working in Swindon by 1880, and by 1887 were in a Gospel Hall in Bridge Street. They used this as a base to hold services in the Mechanics' Institute. In 1891, the Salvation Army built their new citadel in Fleet Street, next to the Foresters Arms, a notorious beerhouse. Part of the Army's fortress-like building can be seen in this old picture, taken around 1910. About fifteen years later, J. Grove & Sons, beer, wine and spirit merchant's, opened their Weymouth Stores in the eccentric little premises next door at No. 22. It was managed by Annie Pryce, the widow of a Prudential Assurance Company agent who had latterly gone into the hotel trade. What a delicious irony is conjured up by the juxtaposition of these buildings, of which nothing now remains.

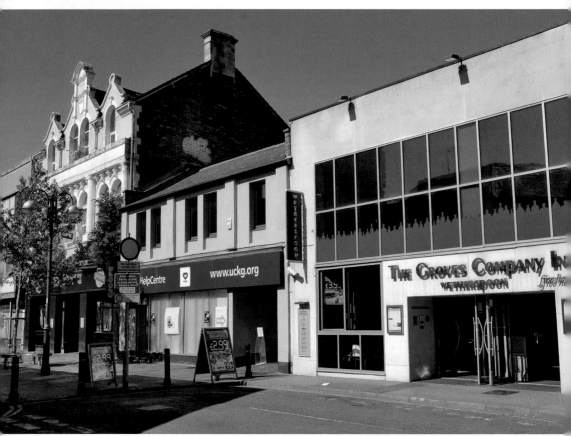

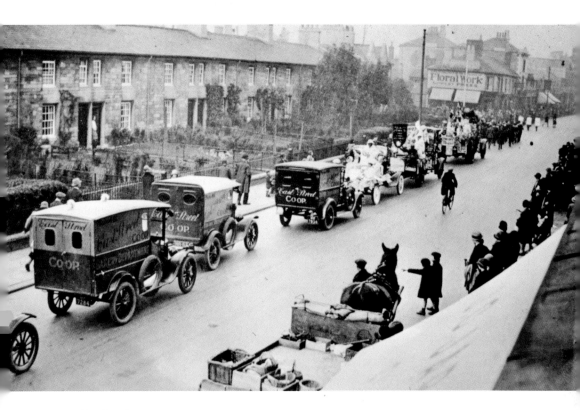

Emerging Services

The Swindon Fire Brigade's Cromwell Street fire station was custom-built in 1901. Crowds gather as its horses and carts leave the premises, photographed by William Hooper from above No. 6, the shop he acquired in 1906. The Swindon Co-op, whose headquarters were in East Street, parades its vehicles in a procession of around the same period, driving past the terrace of cottages and front gardens in Faringdon Road.

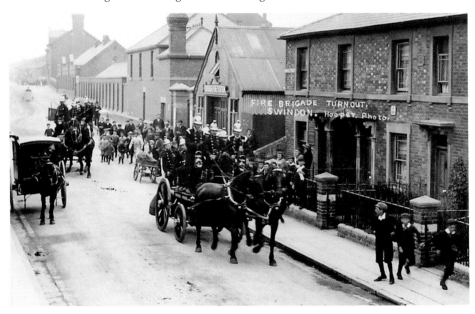

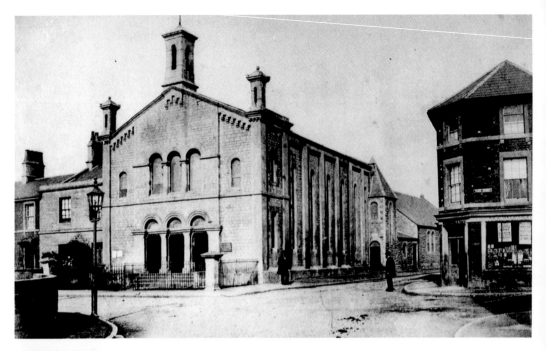

Grand Entrance

The Baptist community in New Swindon built this Italianate chapel on the corner of Bridge Street and Fleet Street in 1849. The instigator of the enterprise was Revd Richard Breeze, who lived in the house next door, and the architect of the chapel was Sir Samuel Morton Peto. A schoolroom was designed by Thomas Smith Lansdown, architect of Bath Road, and built at the rear in Bridge Street. The church purchased Revd Breeze's house in 1861, sold it on, and it became a shop. By the 1880s the New Swindon Baptist community had outgrown the Fleet Street premises and relocated, in 1886, to the tabernacle close to Regent Circus. The chapel was almost completely demolished the following year, and four shops were built on the site. All that remains of the Fleet Street building is part of the former Baptist schoolroom, and some decorative work on the wall behind.

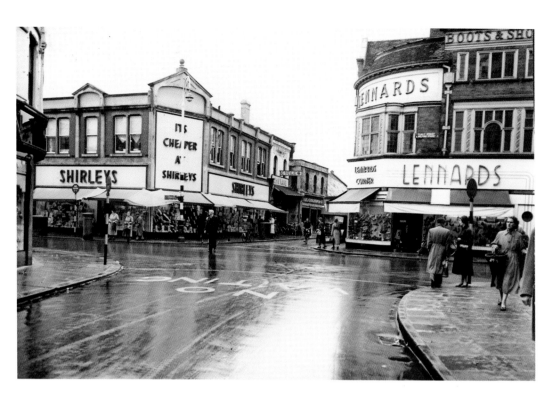

The Face of a Survivor

The site of the Baptist chapel was built up for trade. Several different businesses have gone in over the last century or so, each adapting the premises at street level according to their needs, although the upper façade has remained remarkably unchanged. Adjacent shops and other premises, which were built out of late Victorian residential terraces, have been swept away and replaced by characterless rectangles.

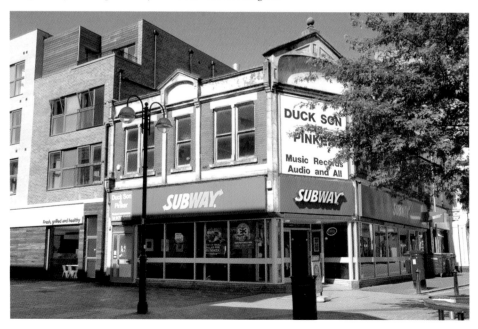

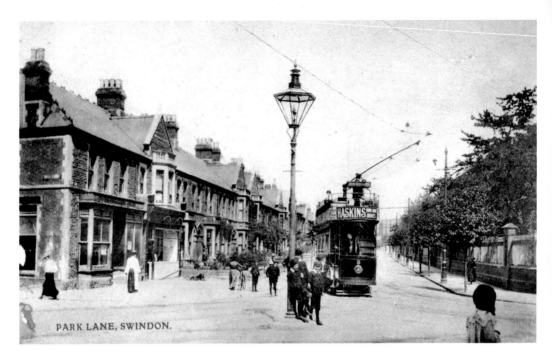

PARK LANE, SWINDON.

Park and Pride

When it began to be built up, around 1888, Park Lane had just one dwelling. This road into Rodbourne (from 1904 the tram route), ran beside the railway company's park and cricket ground. These aspirational terraces were built with bay windows to overlook the park, and brick walls with iron railings to complement what was opposite. The shop premises at the Faringdon Road end have remained in trade.

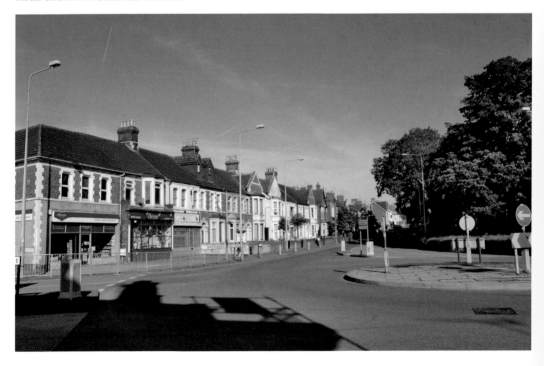

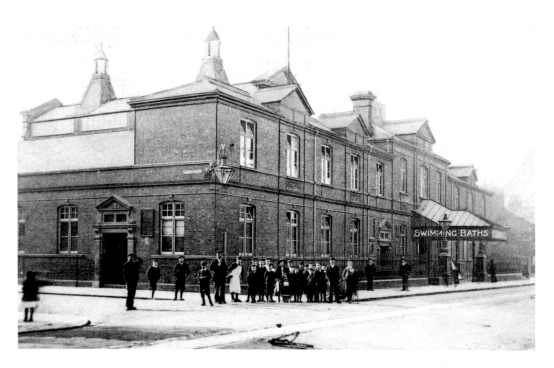

Bathing Beauty

The GWR's Medical Fund Society built its swimming baths, fronting Faringdon Road, in 1892. The larger bath was for the use of men, and the smaller bath was for women and children. The large bath, when covered, was used for meetings, dinners, concerts and public dances. The external walls to Milton Road still have the metal rings that were once used for tethering horses, now put to the same use for bicycles.

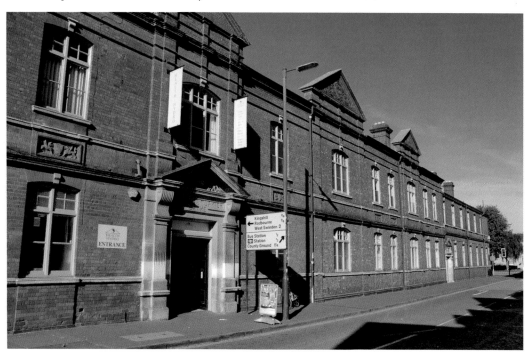

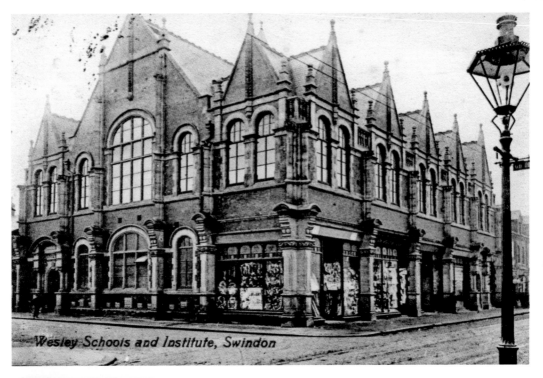

Wesley Schools and Institute, Swindon

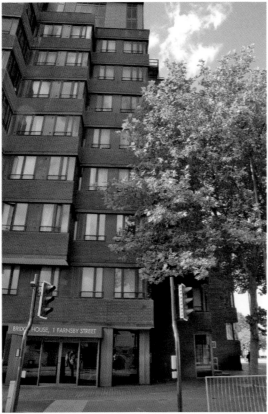

BRIDGE HOUSE, 1 FARNSBY STREET

Grand and Gabled

The imposing, slender-gabled Wesleyan Methodist Schools and Institute was built in the 1880s on the corner of Faringdon Street (later Road) and Farnsby Street. The attention to detail was impressive, from the treatment of the paired windows above with their forest of flanking pinnacles, to the heavy, ornamental buttresses that gave a sonorous stability at street level. Several businesses went in on the ground floor: notably during the 1920s and '30s Walter Slocombe's 'Retlaw Cycle Company' on the corner. Variously, this was a bookseller and stationer, and then a fast-food outlet. Today, the site of this beautiful building is occupied by a multistorey block built in 1975 as offices for W. H. Smith, and named Bridge House after their premises in Lambeth, London. These offices were converted to apartments in 2006.

84

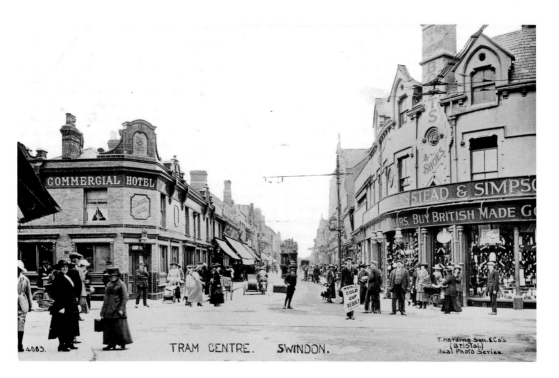

All Aboard

This was the tram centre, known as Clappen's Corner after 1881 when William Clappen set up his boot and shoe business there, opposite what was then the Volunteer Hotel. From 1904, trams from Old Town continued either to Bruce Street, Rodbourne or the Duke public house in Gorse Hill. Clappen's premises were taken over by Stead & Simpson around the time of the First World War.

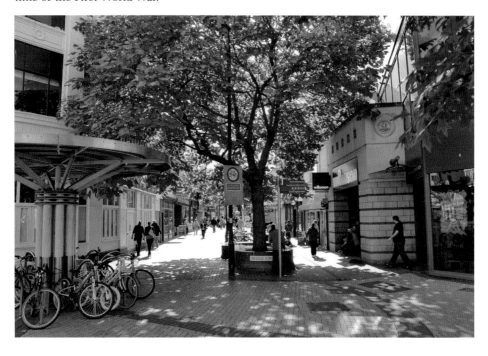

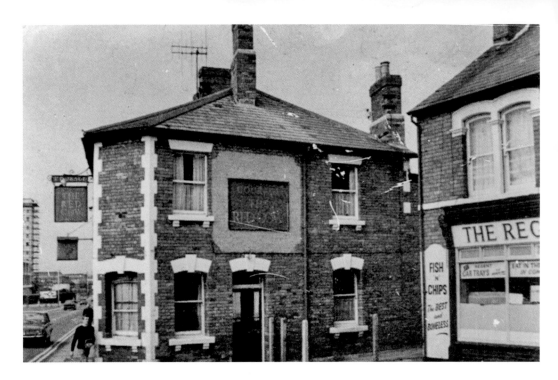

How Now Red Cow

The Red Cow, built in the 1870s, and the Regent fish bar, at the Regent Circus end of Princes Street, pictured in the 1960s. Both were demolished before the end of the decade. Until it was all swept away, Princes Street comprised hardly broken terraces of small brick-built houses and occasional shops. Large office blocks, some now converted to apartments, went up in their place.

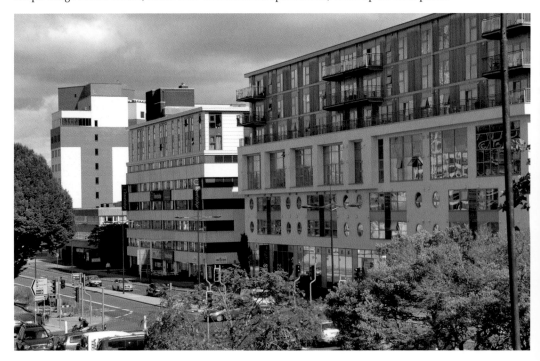

Mover and Shaker

The Sir Daniel Arms was named after Daniel Gooch, the GWR's locomotive superintendent and the man generally credited with being the prime influence in establishing the GWR's locomotive works at Swindon. He also became the first president of Swindon's Mechanics' Institution, although he never lived in the town, despite becoming Member of Parliament for Cricklade, the constituency that Swindon was in at the time. The public house bearing his name opened in Fleet Street in the late 1860s, and was demolished in 2000. Seven years later, the new
Sir Daniel Arms was built next to the space where the original pub had been, on a part of the street that had become pedestrianised since the demise of the pub. Daniel Gooch is also remembered in the name of Gooch Street, built in the 1880s.

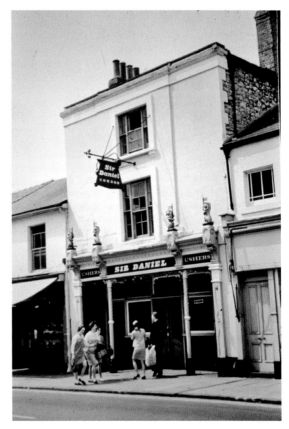

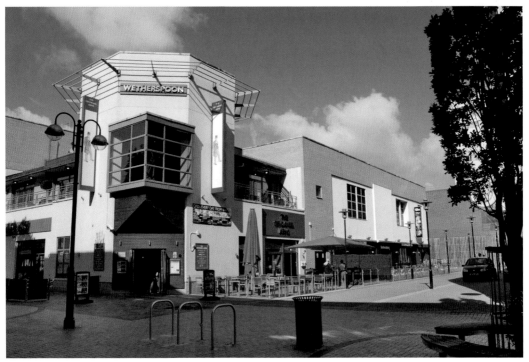

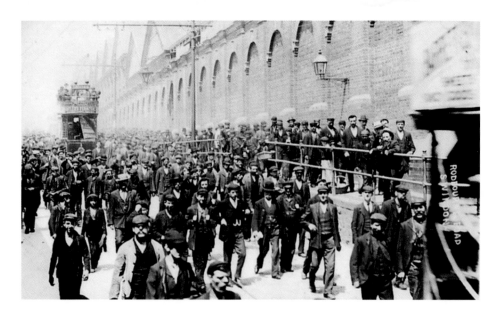

Rivers of Industry

Swindon's locomotive workshops opened in 1841, with a workforce of just 400 men. Ten years later, this had risen to 2,000, and to 16,000 at the start of the twentieth century. The town's photographers were fascinated by the outpouring of men at the end of their shifts, and these are just two examples, taken when Swindon really was a one-industry town. It took two world wars to change that.

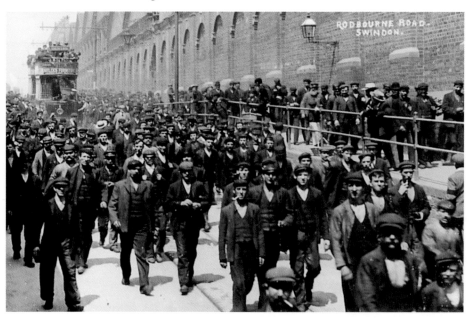

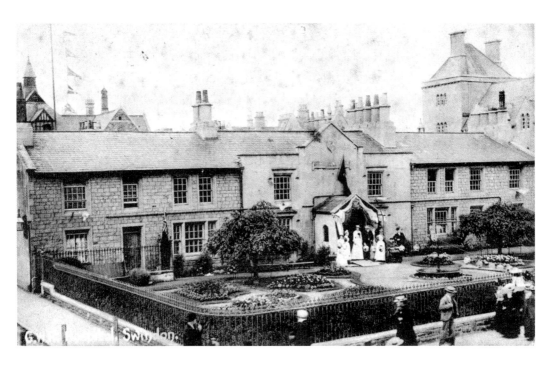

Recovery

In 1871, some cottages in Faringdon Street (later Road) were converted by the GWR's Medical Fund Society into an accident and emergency hospital to deal with employees who were injured in the railway works. Part of the flower gardens was given over to a hospital extension in 1927. It all closed in 1960, was converted to a social club and has been a community centre since 1979.

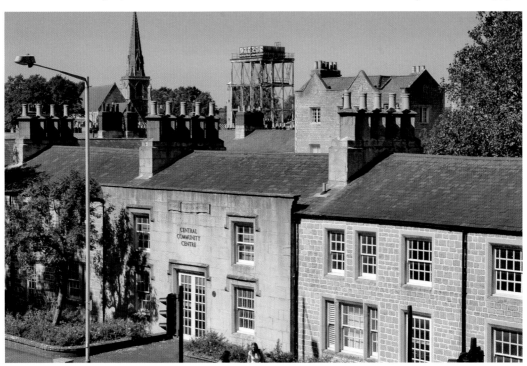

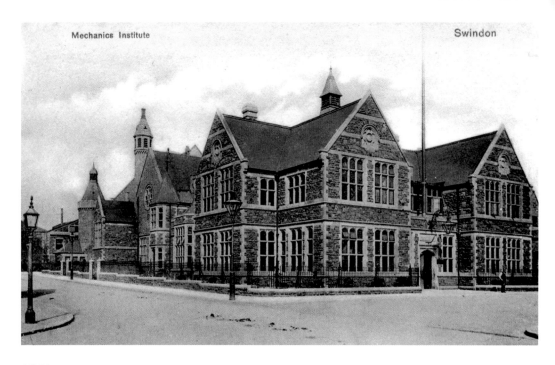

Mechanics Institute

Swindon

All Rise

Two fine views of the Mechanics' Institute, taken from the south-west and the north-east. It was designed by Edward Roberts and opened in 1855, and was enlarged fifty years later. It had a reading room, a library, a coffee room, a dining room, and a lecture hall with a stage. Following a fire in 1930, part was remodelled as the Playhouse Theatre. The building was sold to a private developer in 1986.

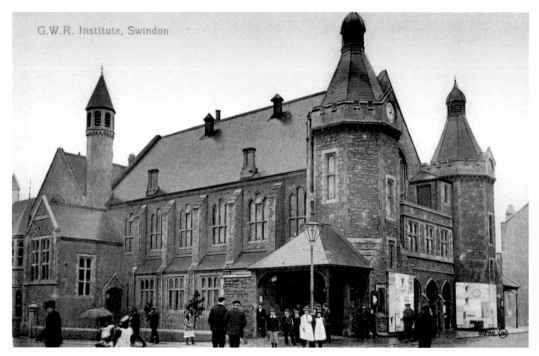

G.W.R. Institute, Swindon

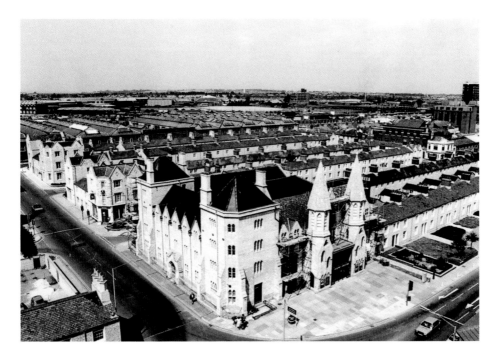

Young, Single and Handsome

The eastern section of the railway village was built 1845–47, and the 'barracks', which was opened in 1851 when it was intended to accommodate single young men employed in the GWR Works, became the focal point. Unsuccessful as lodgings, it became a Wesleyan Methodist chapel in 1868, and the Swindon Railway Museum from 1962. It is now a centre for young people.

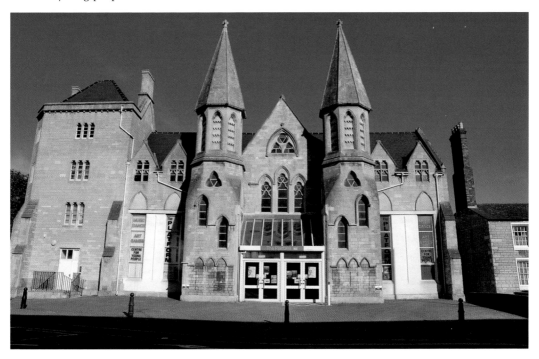

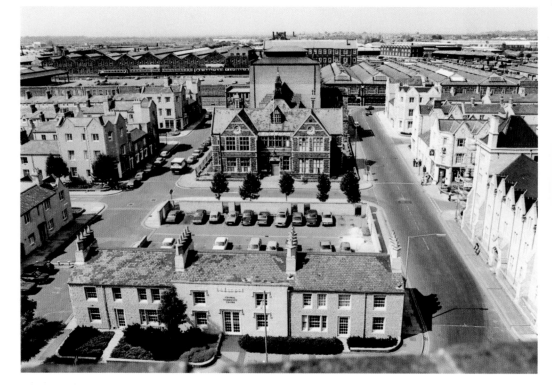

Sticking Point

The central section of the railway village, photographed in the 1980s, shows Emlyn Square, originally High Street, the juxtaposition of the Mechanics' Institute, cottage hospital, and the former 'barracks'. The Glue Pot was built as a house and shop in the 1840s, and was converted to a pub around 1850. It was once called the London Stout Tavern.

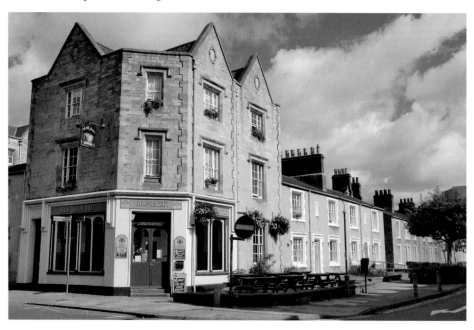

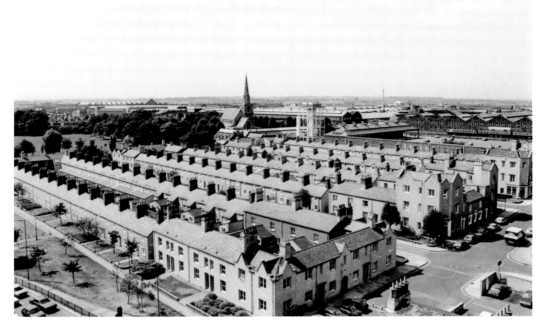

Thirsty Work

The western section of the railway village was built between 1841 and 1843. This picture shows St Mark's church of 1845 and the 50,000-gallon water tower that the company built in 1871. Although the railway village had its own pubs, the Queen's Tap, opposite the station and built in 1841, refreshed many workers. In isolation then, it is now dwarfed by multistorey buildings.

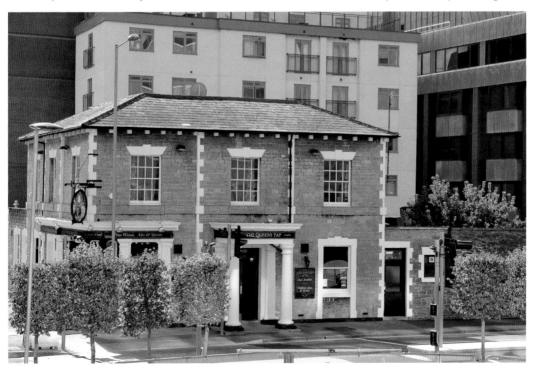

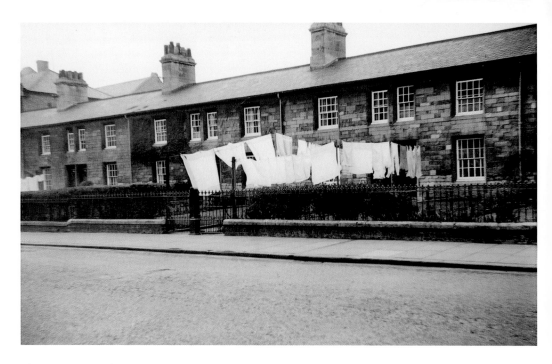

Pleasant Impressions

This Faringdon Street (later Road) terrace, built in 1847 as part of the GWR model village, had substantial front gardens, suggesting, erroneously, that such might be found throughout the estate. The GWR liked to create the best impression with properties that faced its line, and the public highway. The gardens are now gone, their place taken by the greening of central Swindon.

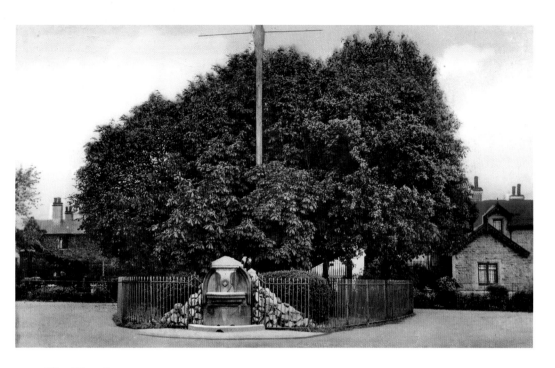

Fête Attraction

The Park began as a cricket ground, upon which the Mechanics' Institution held the first of its annual children's fêtes in 1866, before a pavilion was built and the New Swindon Cricket Team was established there the following year. A keeper's lodge was built, a bandstand erected, and formal ornamental gardens were laid out in the 1870s, which eventually included fountains, drinking water troughs and walkways.

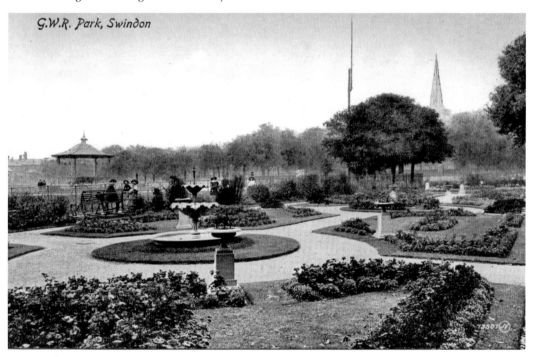

G.W.R. Park, Swindon

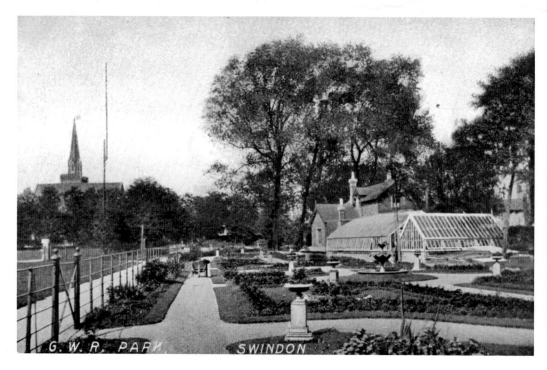

Informal Setting

The Mechanics' Institution's Park Improvement Committee controlled the Park until they handed it over to Swindon Corporation in 1925. The last annual juvenile fête took place there in 1939, although it has recently been revived. The keeper's lodge, greenhouses and all formal gardens were removed, leaving an area that is today less colourful on the eye, but wilder and more attractive to wildlife.

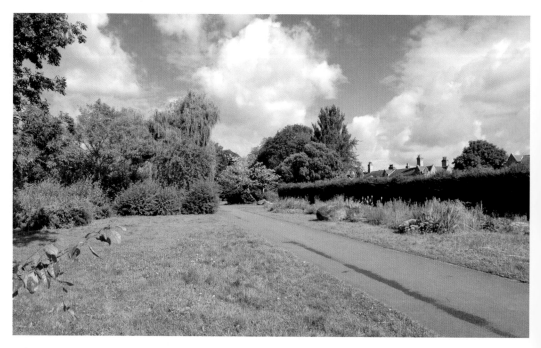